THE ART OF DRAWING

Drawing Scenery

LANDSCAPES, SEASCAPES AND BUILDINGS

Giovanni Civardi

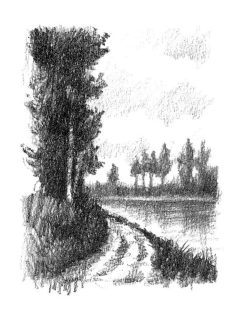

SEARCH PRESS

First published in Great Britain 2002 by Search Press Limited,
Wellwood, North Farm Road, Tunbridge Wells, Kent TN2 3DR

Reprinted 2006

Originally published in Italy 1993 by Il Castello Collane Tecniche,
Milano

Copyright © Il Castello Collane Tecniche, Milano 1993

English translation by Julie Carbonara

English translation copyright © Search Press Limited 2002

ISBN 1 903975 10 7

Design by Grazia Cortese

INTRODUCTION

By focusing on drawing scenery, this book avoids any arguments over the definition of 'landscape'. Scenery is all-encompassing. It includes natural features such as plants, trees, rivers, seas and mountains, as well as the whole environment, both rural and urban, in which man and animals live, and which man has changed through cultivation and construction. In this book, scenery includes landscapes, seascapes and buildings, though none is mutually exclusive. You only need look at the history of painting to realise the importance – past and present – of the 'landscape' genre and the sometimes profoundly different ways it has been perceived and interpreted by artists over the centuries.

To paint well, you need to draw well. The artist needs to know at least the basics of perspective and composition. The aim is not to achieve a sterile and academic result for its own sake, but to learn the art of drawing in order to be able to bend it and shape it to your artistic needs, or if necessary to reject it altogether.

This second book in the Art of Drawing series (the first one deals with drawing techniques and tools) is an attempt to offer a simple and concise overview of the many aspects of drawing scenery, highlighting some of the problems a beginner will be faced with, and giving pointers (based on my teaching experience) on how to approach them to achieve good results. To this end, it is important to note that, besides learning and experimenting with drawing techniques, one needs to learn to 'see' reality – what surrounds us – in order to be able to translate graphically what we perceive. I have included a number of photographs alongside the drawings and diagrams to give a gallery of sample images so that, if you lack the opportunity to study scenes 'from life', you can start practising – in the styles and with the techniques you like – without being influenced by my style of drawing.

TOOLS AND TECHNIQUES

Simple and popular media such as pencils, charcoal, pastels, pen and ink, watercolours, felt-pens, etc., can all be used for drawing scenery. Each medium, however, gives different results, due not only to the specific characteristics of the material and the techniques used, but also to the drawing surface: rough or smooth paper, canvas, white or coloured paper, etc. The drawings shown on these two pages have been done with media which, although commonly used, effectively convey nature's tonal complexity, shades and details.

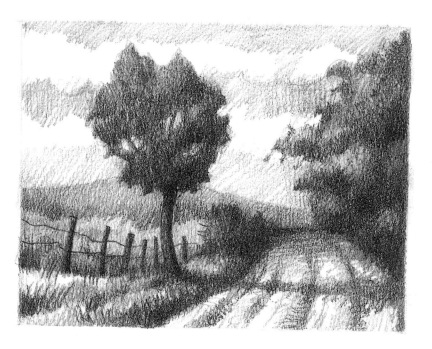

Pencil (H; B; 2B) on rough paper

Pencil is the medium most commonly used for any type of drawing, but it is particularly suited to drawing scenery as it allows spontaneity and is convenient to use. It can be used for complex drawings, or for small studies and rough reference sketches. For the latter very fine graphite (lead) is suitable, while for the former you can use thicker graphites in a softer grade. Graphites in mechanical holders as well as pencils (graphites in a wooden casing), are graded according to their consistency: from 9H (very hard) to 6B (very soft).

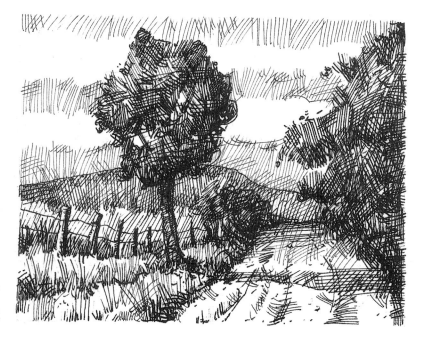

Pen, nib and Indian ink on medium-rough paper

Ink is also often used by artists. It can be applied with a brush, or a nib, but to obtain special effects you can use bamboo reeds, oversized nibs, quills, or a small sponge to make marks. Tones can be made more, or less, intense by varying the density of the cross-hatching and it is therefore advisable to draw on fairly smooth, good quality paper (or board) which will not fray or soak up ink. For drawing out of doors, fountain pens, 'technical' pens, felt-pens and ball-point pens are the most suitable.

Compressed charcoal on Rough paper

Charcoal is perhaps the ideal medium for drawing scenery as it is easy to control when laying out tones, and allows the artist to achieve quite sharp detail. To exploit its versatility and its evocative power, however, it should be used 'broadly', concentrating on the overall rendering of 'shapes'. Compressed, rather than willow charcoal, is also a handy medium when drawing outdoors, although you have to take care not to smudge the paper. Charcoal strokes can be blended and smudged by rubbing with a finger, and tones can be softened by blotting with a soft eraser (a kneadable putty eraser). When completed, the drawing can be protected by spraying it with fixative.

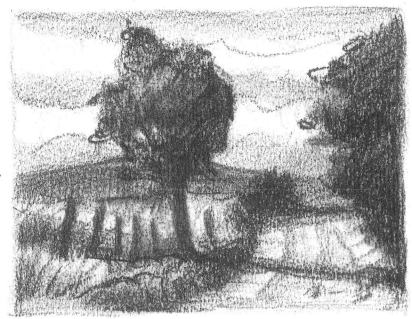

Diluted ink on Not paper

Watercolours, water-soluble inks and water-diluted Indian ink are very suitable for drawing scenery, in spite of being closer to painting than to drawing as they use a brush and require a comprehensive and expressive tonal vision. For quick, outdoor studies you can use water-soluble graphite or coloured pencils (to blend strokes easily, wipe them with a water-soaked brush); it is also preferable to stretch your paper so that the surface does not cockle.

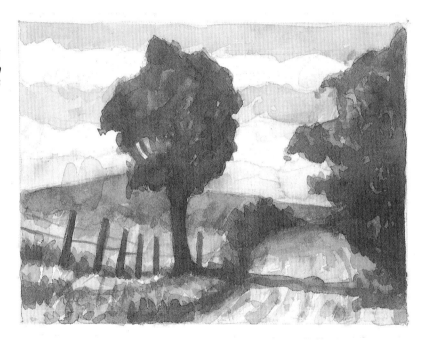

Pen and ink, watercolours, and white tempera on coloured paper

'Mixed' media means using different materials to achieve a drawing with unusual effects. Although still 'graphic' materials, their more complex application requires good control, and a good knowledge of the tools themselves, if we are to avoid muddled results of little aesthetic meaning. Mixed media are very effective on textured and coloured – or dark – surfaces.

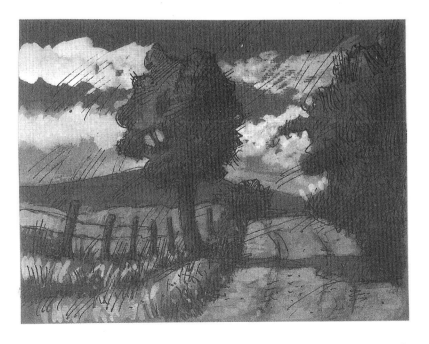

PRACTICAL ADVICE

There are opportunities for drawing scenery all around us. Many famous artists drew and painted what they saw from the window of their study or from the hotel they in stayed during their trips. Part of the pleasure of drawing, however, lies in the search, even far away, for a suitable, 'inspiring' subject. You may happen upon interesting vistas from a train, or bus. Some people have even painted scenes from a plane. But much more often, you will explore on foot, by bike or by car – the true 'landscape artist' is one who works outdoors, *en plein air*.

DRAWING OUTDOORS

If you intend to draw outdoors you can expect adverse or irritating situations to occur and you will have to take care of them.

A common problem is a psychological one. You will have to overcome the unease which comes from working while being watched by curious passers-by or boisterous children. Don't worry: you will also meet interesting people!

The weather can also cause problems. Make sure you take the right type of clothing for the season: comfortable shoes, a hat, and a large umbrella in neutral colours for working in the shade or sheltering from the rain. If the weather is bad you can even draw from inside your car, sheltered from rain, wind and cold.

If you travel on roads with little traffic, take care when stopping and looking around.

EQUIPMENT

For essential information on drawing techniques and equipment, I suggest that you read the first book in this series: *Drawing Techniques: Pencil, Charcoal and Ink*.

When working outdoors a folding chair, a few soft pencils (or whichever media you have chosen), and a sketchbook made of good quality paper are useful. If you do not have a sketchbook, you can fasten single sheets [quarter sheets, 380 x 280mm (15 x 11in) are ideal] on board with some tape.

Carry a small bag as well to hold (besides the appropriate drawing tools), a bottle of water, a few rags or paper tissues to clean your hands, drink and food for a revitalising snack.

DRAWING TECHNIQUES

As I said above, drawing techniques are covered in the first book of this series, but let us recap a few points for those readers who have just started to learn about drawing.

For good results, make sure that you always keep your pencils sharpened with a knife or a pencil sharpener. To keep graphites in mechanical holders well sharpened, rub and roll them on a piece of sandpaper. Very fine leads and charcoal do not need sharpening.

If you want to draw wide strokes, hold the pencil at an acute angle to the drawing surface. Placing a sheet of tracing paper under your hand while you work will protect your pencil or charcoal drawings from smudging. When you have finished working, spray the whole drawing with an appropriate 'fixative'.

Never use an eraser. If a stroke has not worked, do not erase it. Draw another close to it to correct it and, if necessary, a third one and so on, until you have achieved the result you want. If you erase the imperfect lines, you will be left without terms of reference by which to make your alterations, and it will be like having to draw a new line. Basically, you will not be able to 'use' the imperfection as the basis for making your change. When you are happy, you can trace the correct lines with firmer strokes and erase the wrong ones.

Indian ink becomes viscous if the container is left open for long. You therefore need to add one or two drops of water occasionally. For the same reason, nibs should be cleaned often with a rag. Remember that clean nibs glide more easily on fairly smooth paper.

Do not work on a drawing for too long without taking a break. Every now and then stop, let your mind wander a little and examine what you have done from a distance.

CHOOSING A SCENE

Choosing a scene to draw from life is fairly difficult, because only rarely do you manage to catch it in ideal conditions so that it is more than just generically interesting. If you are studying particular features (for example, trees, clouds or water) or carrying out a simple technical exercise, all you have to do is to observe the individual element carefully. But if your drawing is to be followed by a more complex one in preparation for a painting, or aims for an aesthetic meaning of its own, or is intended to analyse the complexities of perspective and composition, you need to spend more time observing the scene carefully before you start drawing it. Do this even if your work will be limited to rough sketches to capture the basic elements.

PLANNING A SCENE

When you reach a spot that looks promising, do not settle for what you see immediately but, if possible, walk slowly in different directions looking at the scene from different viewpoints (for example, you could sit on the ground or stand on a low wall).

At each location draw quick little sketches that outline the main 'shapes' – light and dark – of the scene (sketch them without worrying about the exact shape of the objects, concentrating instead on their tonal contrast, their relative dimensions, and their proportional relationship); evaluate the 'format' of the drawing (that is, whether it is more effective as a landscape or a portrait). Organise the composition, and insert or eliminate certain elements (see pages 20, 22 and 34), choosing a close-up, detailed view or a panoramic, concise view.

The time you spend planning (observing, moving around, sketching, selecting, etc.) is not wasted. On the contrary, it is extremely useful as it solves perspective and compositional problems, highlights the feelings and emotions a certain landscape inspires in us, and lessens that 'fear of emptiness' we are all likely to feel when we are faced with a blank sheet and we do not know where to start.

LEARNING FROM OTHERS

It can be both enjoyable and informative to get together with fellow artists interested in drawing scenery and to go on outings. On these occasions each artist pursues his or her aims and keeps to his or her style, but the fact that everyone is working on the same subject, in the same conditions, using different media from slightly different viewpoints, allows interesting comparisons and useful exchanges of opinion, as people learn not only from their own experience but also from that of others.

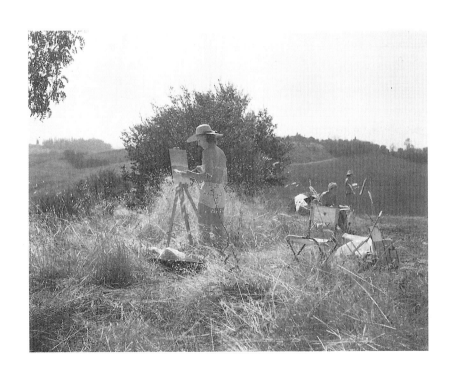

LINEAR PERSPECTIVE

Perspective is a graphic method which represents spatial depth on a flat surface. In this chapter I have summarised the geometrical principles of linear perspective, whereby you achieve the effect of spatial recession through the decreasing size of the objects represented. Following these simple principles the artist can correct, or better understand, the 'intuitive' perspective naturally perceived by the eye.

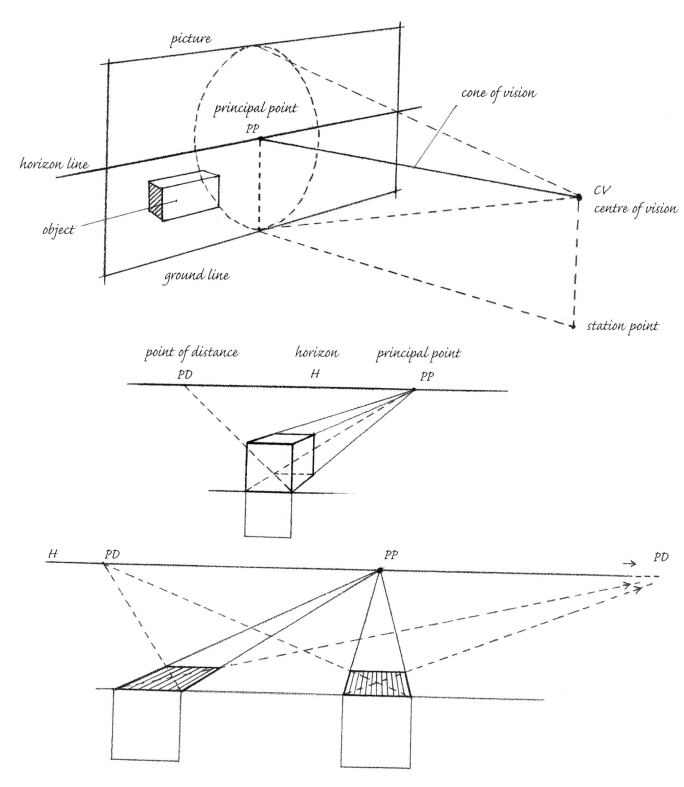

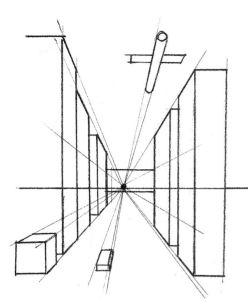

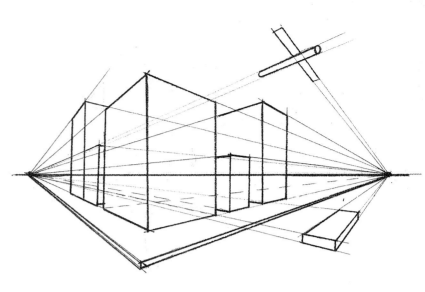

Central (or parallel) linear perspective is based on the principle that the non-vertical parallel lines converge on a single point in the distance. The horizon line always corresponds to the height of the viewer's eye and is determined by the viewpoint, i.e. by the position from which you are looking at an object or a scene.

Angular (or western) linear perspective, on the other hand, considers two vanishing points, positioned towards opposite ends of the horizon line. The objects (which for simplicity's sake are represented as geometric solids) are viewed from the side. Vertical lines remain vertical, but their height appears to diminish towards the horizon and they also appear to decrease in depth. Horizontal lines converge at one of the lateral vanishing points, showing the objects 'foreshortened'.

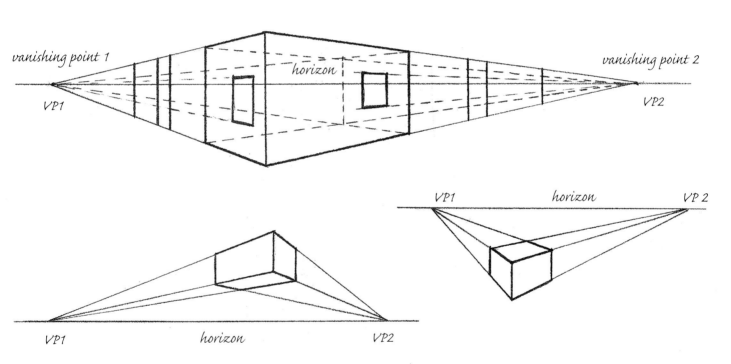

vanishing point 1

horizon

vanishing point 2

VP1

VP2

VP1 horizon VP 2

VP1 horizon VP2

The sketch shown on the right outlines the basic elements that should be considered when drawing scenery. If you hold the drawing surface vertically you will find it easier to draw the horizon line; to compare it with life; and to find the vanishing points. Before sketching a scene – especially if you are going to include buildings and structures – draw a little perspective diagram, so that you can verify, and if necessary amend, what you have perceived intuitively. Remember, however, that perspective is a 'convention'; should not be applied too literally; and should be secondary to aesthetic values.

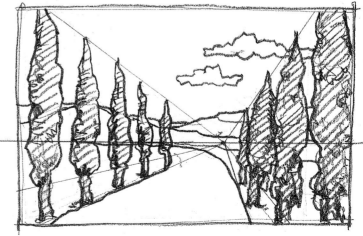

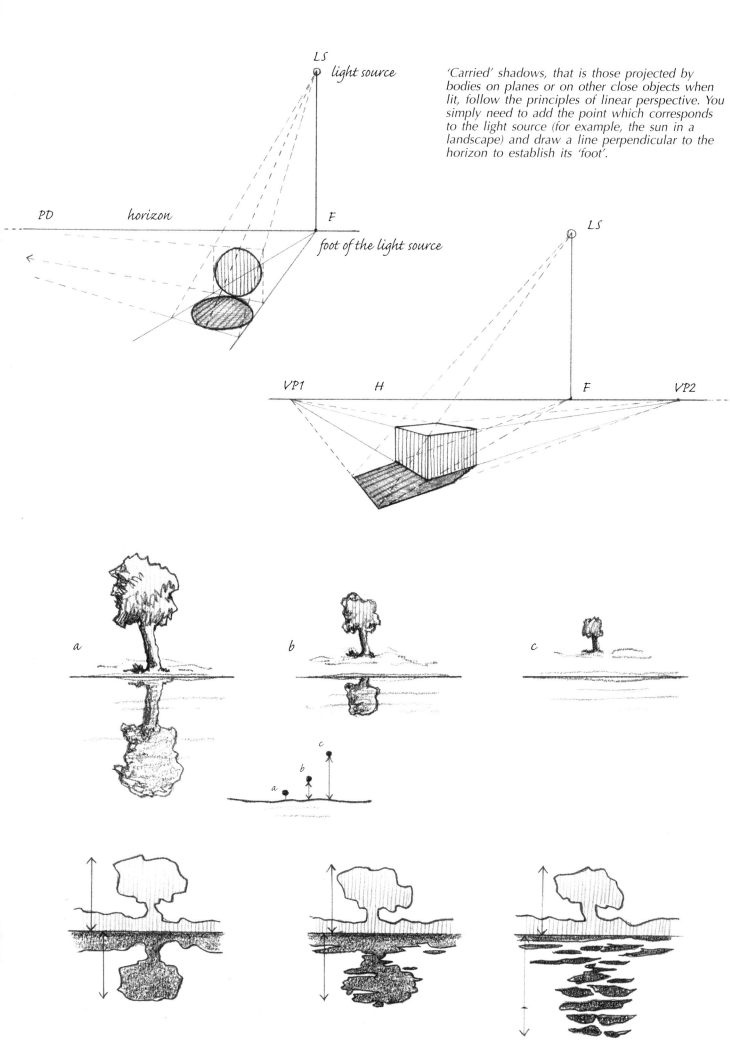

LS
light source

'Carried' shadows, that is those projected by bodies on planes or on other close objects when lit, follow the principles of linear perspective. You simply need to add the point which corresponds to the light source (for example, the sun in a landscape) and draw a line perpendicular to the horizon to establish its 'foot'.

PD horizon F

foot of the light source

LS

VP1 H F VP2

a b c

c

b

a

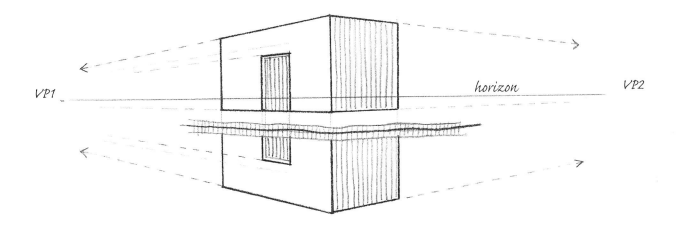

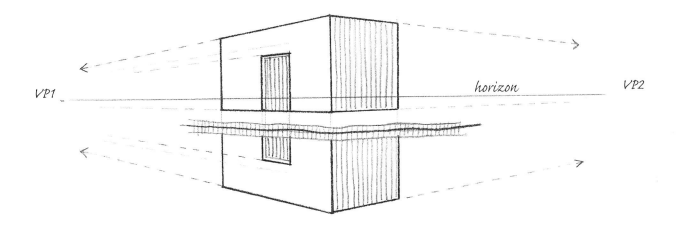

VP1 *horizon* VP2

Water mirrors the objects on its surface, and their outlines can be drawn following the rules of perspective, bearing in mind that the liquid surface is always horizontal. It is, however, extremely useful to observe carefully from life, as reflected images look different depending on the circumstances. They are almost mirror-like if the water is still; they break up if the water is slightly rough, and they almost disappear when the surface is very rough. The sketches at the bottom of page 10 show these effects, as well as the effect of the distance of the object from the water's edge.

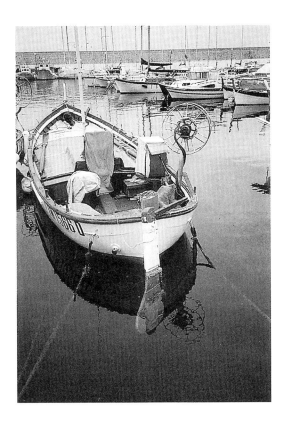

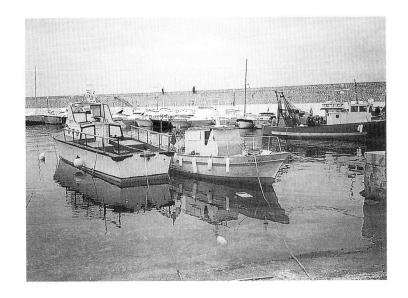

The photographs you see here can be used as a study aid to drawing reflections in some typical situations. My advice is to lay a sheet of tracing paper over the photograph, and draw only the outline of the boats or trees and their reflections on the water. These exercises will help your drawing greatly, especially if you are clever enough to outline just the main waves and breaks and leave out unnecessary fine detail.

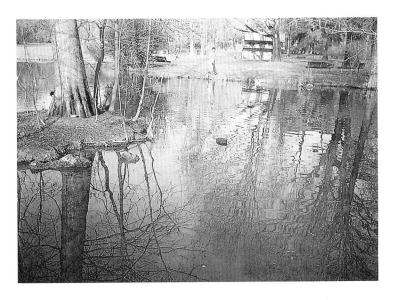

It is good practice, especially when you have just started drawing scenery, to use photographs on which to identify and mark the main elements of perspective: the horizon line; the vanishing points and the spot where the visual lines meet them. If possible, take the photographs yourself and then compare their perspective analysis from life, at the exact location from which you took the photograph.

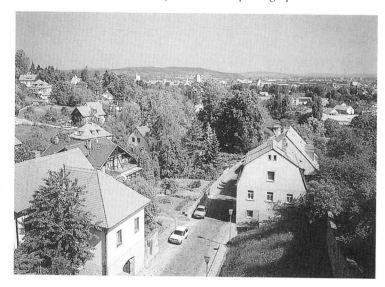

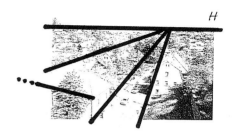

View from above: the horizon is at the top of the drawing.

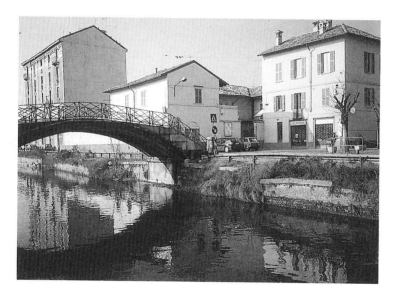

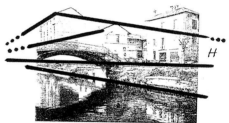

Horizon in the middle: the lateral vanishing points are outside the edges of the photograph.

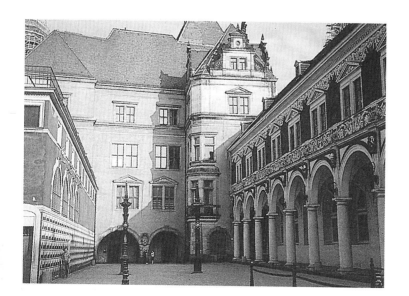

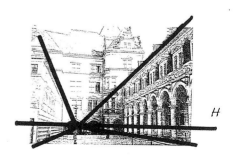

Central perspective.

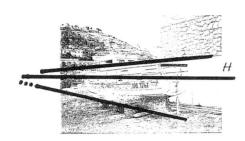

The camera lens can distort the perspective of objects; careful comparison with reality will enable you to make the necessary corrections.

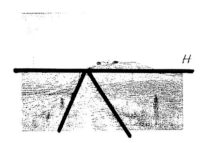

Central perspective.

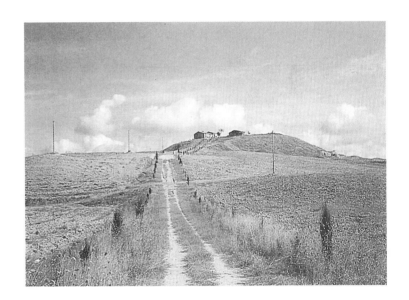

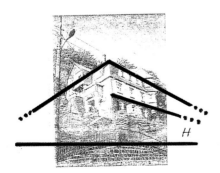

View from below: the horizon is at the bottom of the drawing.

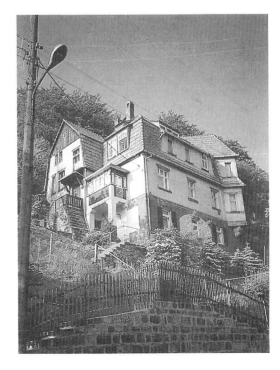

13

AERIAL PERSPECTIVE

Linear perspective does not allow a faithful representation of space within a scene, as objects do not simply seem smaller the further away they are. Their outlines lose sharpness and the air, dust and fumes that come between them and the viewer cause them to lose tonal value, especially where wide vistas are concerned. Tonal, or aerial perspective, takes into consideration these effects and is based on the principle that the elements of a scene, as they recede into the distance, and those close to the horizon, appear gradually lighter, more vague and somehow 'veiled' in relation to the objects in the foreground, near the viewer. The adjacent diagram illustrates this principle. Bear in mind, too, that in a drawing you can create the feeling of depth, of regressing in space, not just by weakening the tones but also by partial superimposition of objects or elements of the scene.

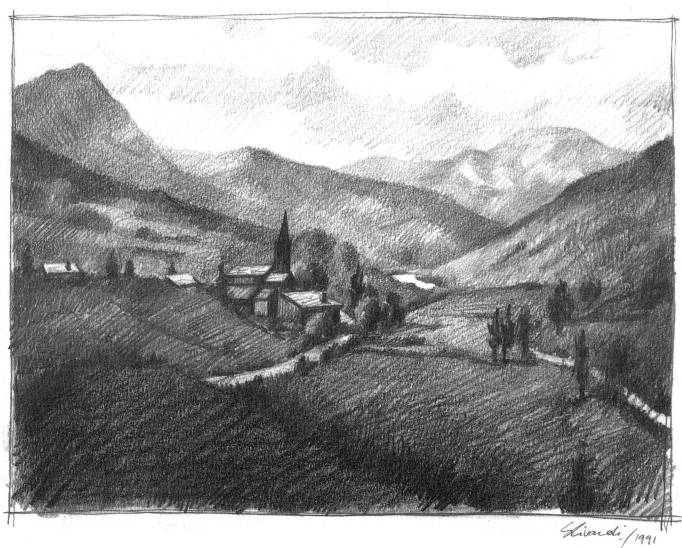

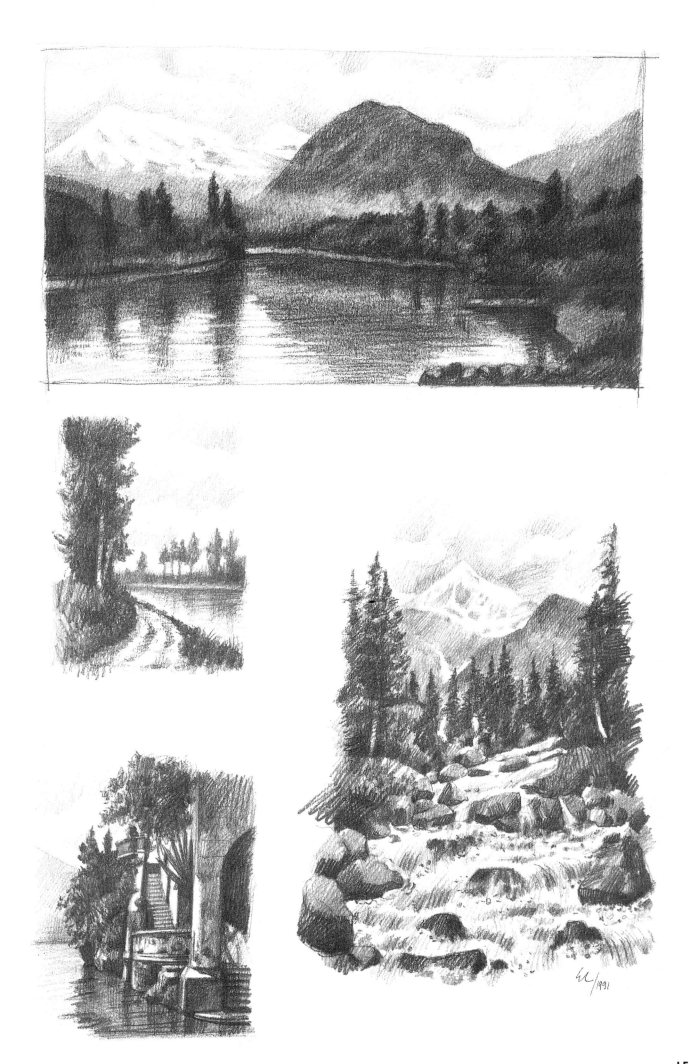

15

Try to find somewhere you can draw from life, or if this is not possible, take photographs similar to the scenes drawn or photographed in this book. If you cannot do this use one of the black and white photographs in this book or from another source. Study carefully the local tones, i.e. the various shades of grey in different areas, and simplify them. To do this, choose only three or four shades between black and the white of the paper. You can use a very soft pencil and make the mark more or less dark by varying the pressure of your hand. A particularly useful exercise is to put a sheet of tracing paper on top of the photograph, then outline the areas that appear to have the same tonal intensity. You may find it quite difficult at first but observing and practising will improve your perception and make the choice of tones in your subsequent drawings easier and more confident.

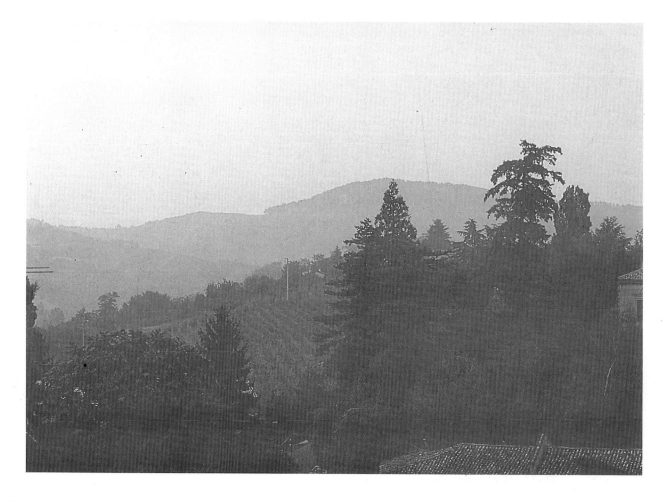

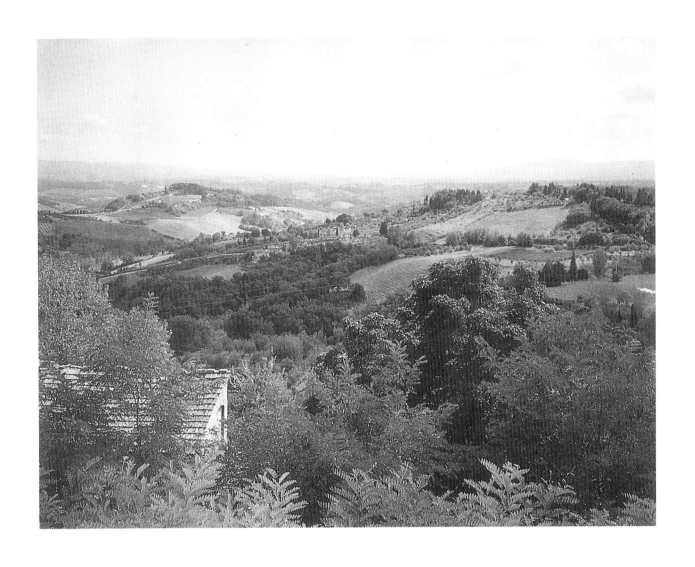

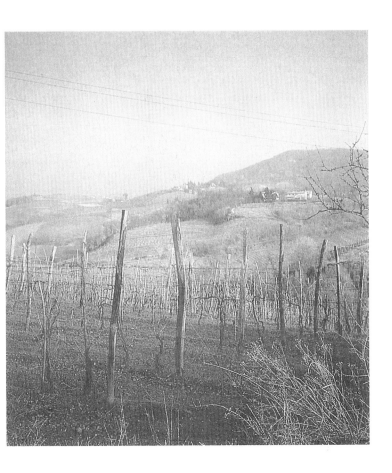

COMPOSING A SCENE

Composing a painting or a drawing means choosing and placing the expressive elements that are to be represented, and organising the way they relate to one another on the drawing surface. Composition depends to a great extent on the artist's intuition and 'visual' education, and is not bound by rules. It is possible, however, by observing works of art from the past or by experimental research, to work out a number of principles and tendencies which best suit our need for harmony and our perception of the environment. The sketches shown on this page are made up of non-figurative elements (as used in research), and review some fundamental principles such as unity, contrast, harmony, convergence, dispersion, etc. At the bottom are some linear 'sequences': horizontal, vertical, diagonal, wavy. Practise drawing similar sketches and try to check their emotional effect: some will inspire feelings of calm, and/or harmony, others tension, others still thickening or rarefying, and so on. On the opposite page I have shown solutions which give better aesthetic results to a number of compositional situations. Bear in mind that these are just suggestions, not rules.

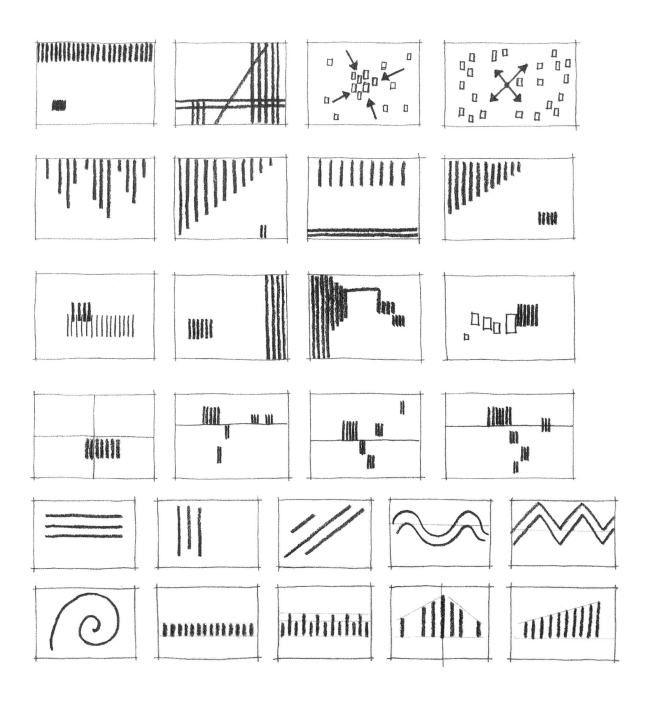

Avoid placing the subject at the centre of the drawing.

Avoid placing the horizon so it cuts the drawing into two equal parts.

Avoid dividing the image into two contrasting (black/white, full/empty, etc.) sections of a similar size.

Leave some 'space' around the subject.

Avoid rigidly symmetrical images.

Break the monotony of horizontal lines by introducing vertical elements.

Avoid lines which converge at the centre of the drawing.

Engineer 'lines of interest' which draw the viewer's eye to the inside of the drawing, rather than outside the edges.

CHOOSING A COMPOSITION

When you start drawing scenery from life you first need to choose a composition, based on the observations in the previous chapter. Composing a scene means evaluating it from different viewpoints in order to understand it in its various aspects and represent it in the most appropriate and satisfying way. Below are some small preliminary sketches and opposite, the viewpoint I have chosen for a more comprehensive study.

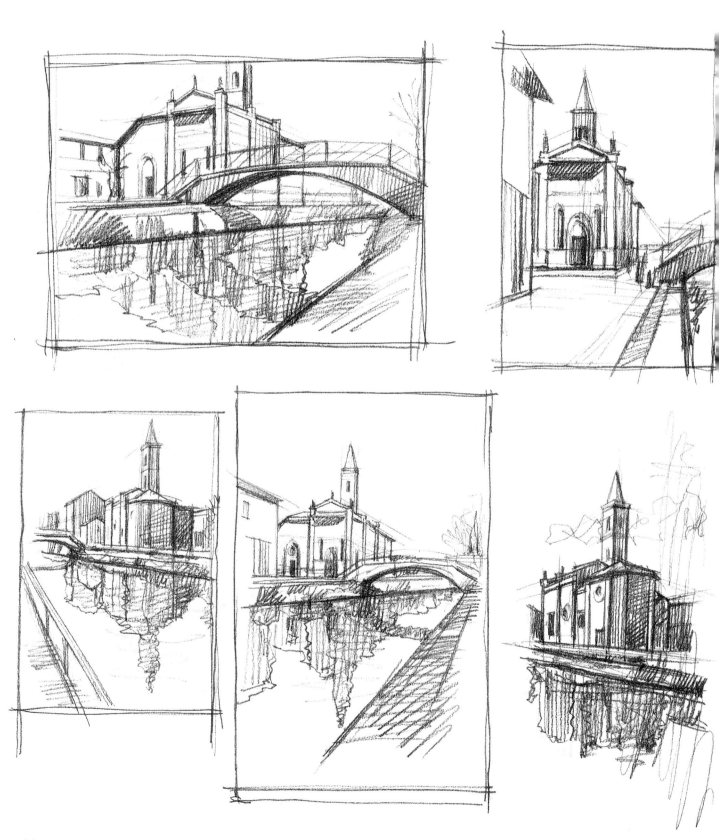

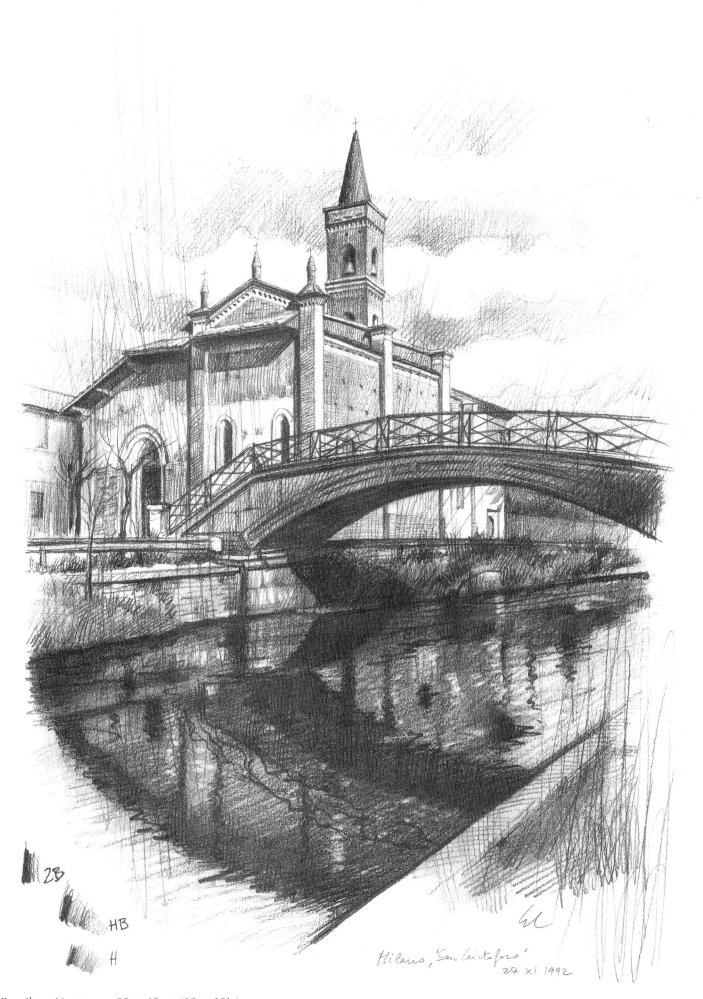

2B

HB

H

Milano, 'San Cristoforo'
27 XI 1992

Pencil on Not paper, 33 x 48cm (13 x 19in).

DRAWING TECHNIQUES

FRAMING

Composing a scene is more than just choosing the right viewpoint. It involves deciding which elements should be put in the drawing, which to leave out or which to change in size or position. It also means 'cropping' the picture, that is choosing the size of the drawing; whether it should be portrait or landscape format and so on (see the diagram below as an example). You may find it easier to use a 'viewfinder' (a little rectangular window cut from a piece of card) through which, by moving it closer or further away from your eye, holding it vertically or horizontally, you can 'frame' the actual scene before deciding which view to draw. Many artists find it easier and more convenient to use an empty slide frame.

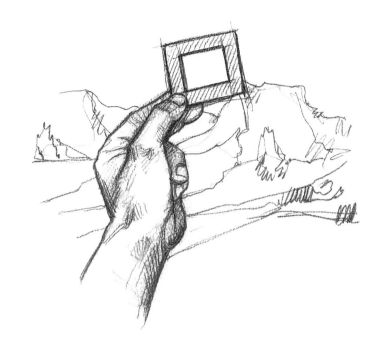

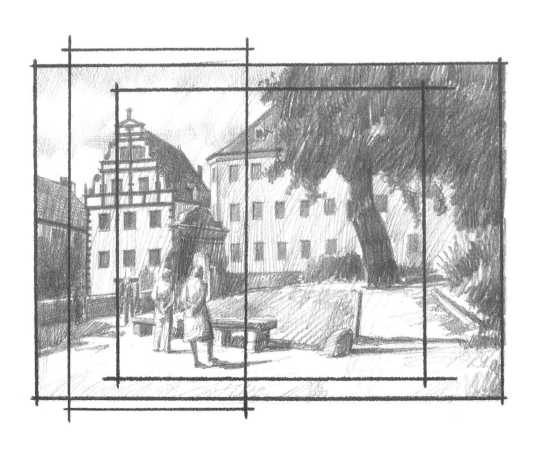

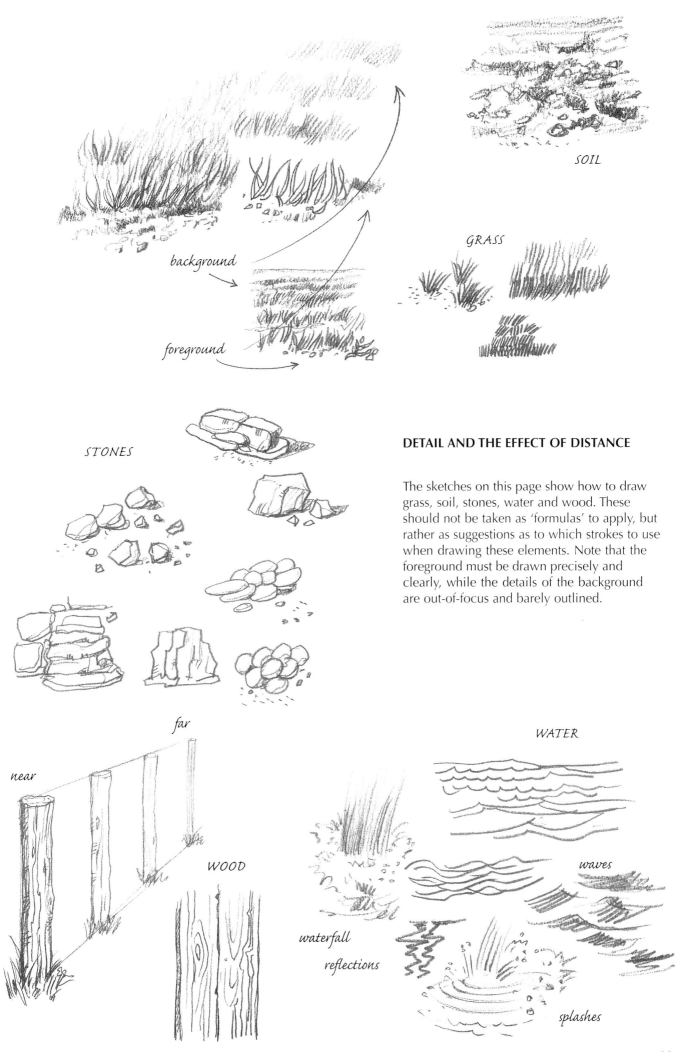

SOIL

background

foreground

GRASS

STONES

DETAIL AND THE EFFECT OF DISTANCE

The sketches on this page show how to draw grass, soil, stones, water and wood. These should not be taken as 'formulas' to apply, but rather as suggestions as to which strokes to use when drawing these elements. Note that the foreground must be drawn precisely and clearly, while the details of the background are out-of-focus and barely outlined.

far

near

WATER

WOOD

waves

waterfall

reflections

splashes

LINE DRAWING

Line drawing can be used to 'build' a scene stage by stage. I start by sketching perspective lines, then outlining the individual elements. I then draw the most important tones and finally add more detailed tones. This is an analytical type of representation, suited to drawing with a pen or hard pencil. On these two pages you can see the four stages of a drawing I sketched from life while on holiday in Germany, when preparing this book. The finished drawing is on pages 26-27.

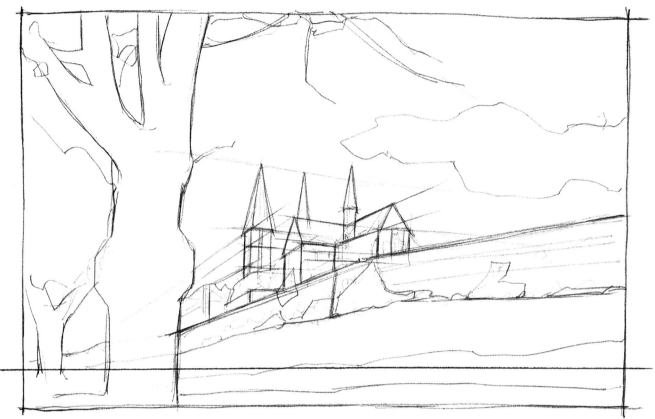

Stage 1 *Perspective lines sketched in.*

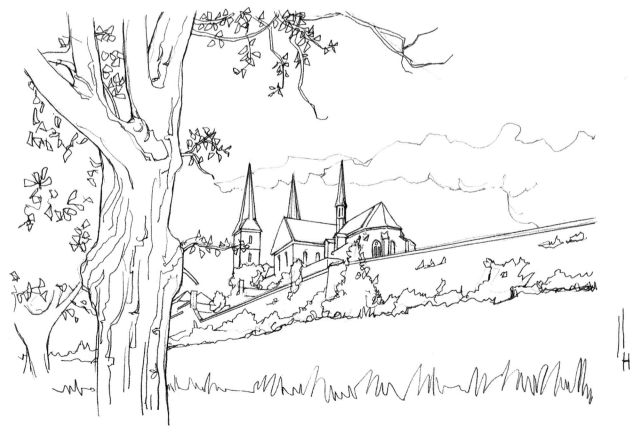

Stage 2 *Individual elements of the scene outlined.*

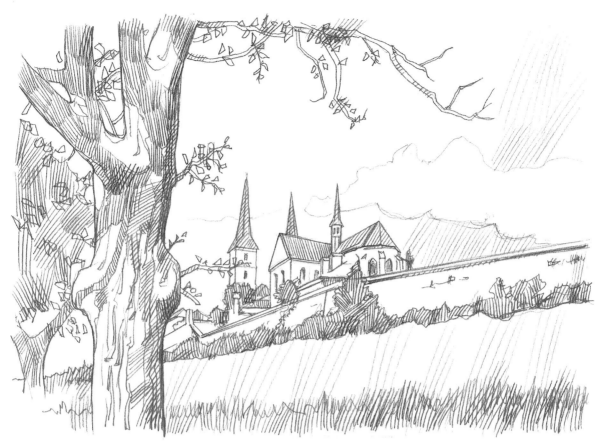

Stage 3 *The most important tones outlined.*

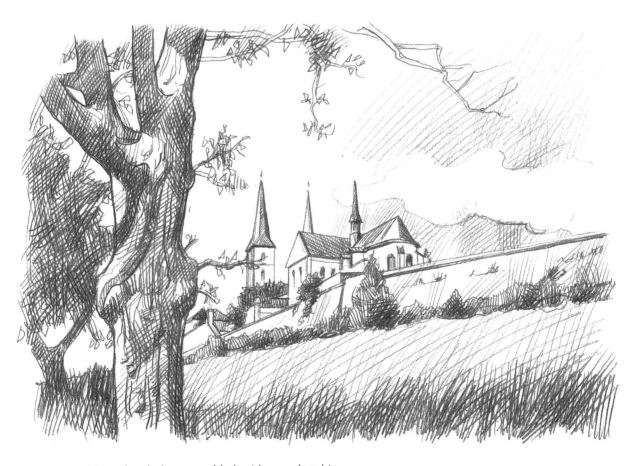

Stage 4 *More detailed tones added with crosshatching.*

25

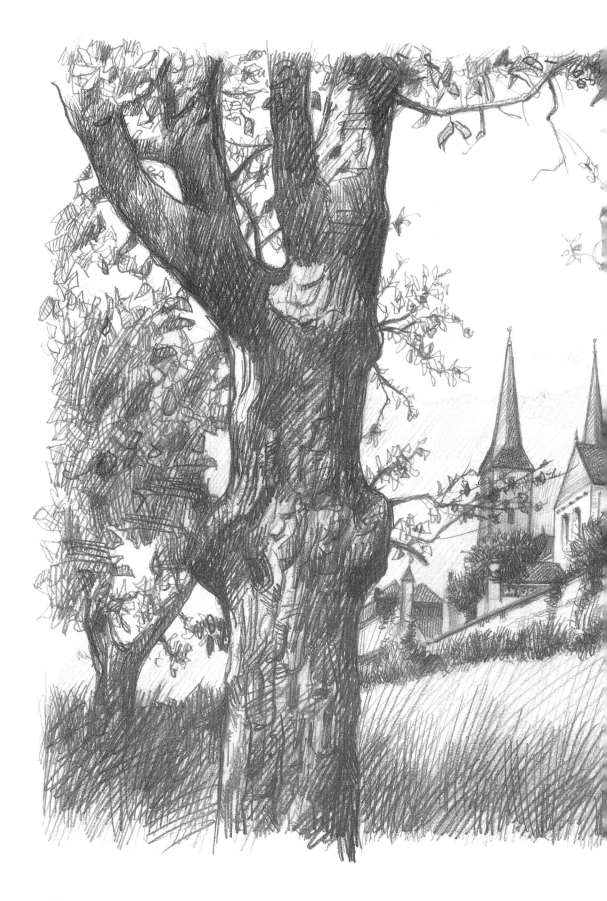

Pencil on Not paper, 33 x 48cm (13 x 19in).

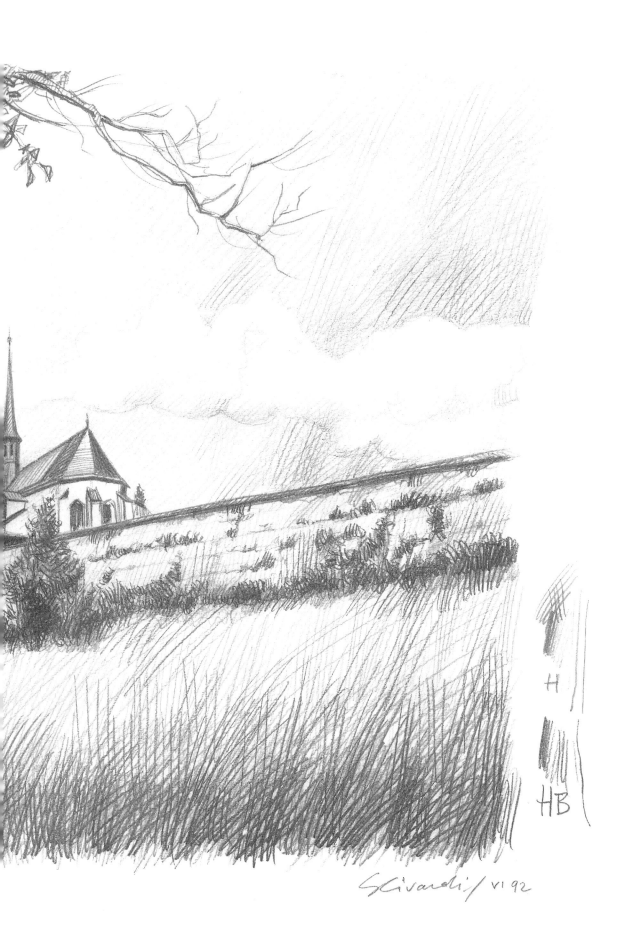

H

HB

Scivardi/ VI 92

27

TONAL DRAWING

Compared with the more 'graphic' line drawing approach, tonal drawing is definitely pictorial. It concentrates on representing the 'shapes' that make up a scene, with a unitary, structured approach which pays more attention to the interplay of tonal values than to minute detail. It is an approach which works well with soft graphite, charcoal, watercolours or mixed media, all of which are well suited to the tonal shading typical of aerial perspective. To demonstrate this method I have, again, included four successive stages and on pages 30-31 the finished drawing. My advice is to try both the linear and tonal approaches, regardless of which style you prefer, and apply them to the same scene, in order to weigh up their different expressive characteristics.

4B

Stage 1 *Rough representation of the overall shape of the scene.*

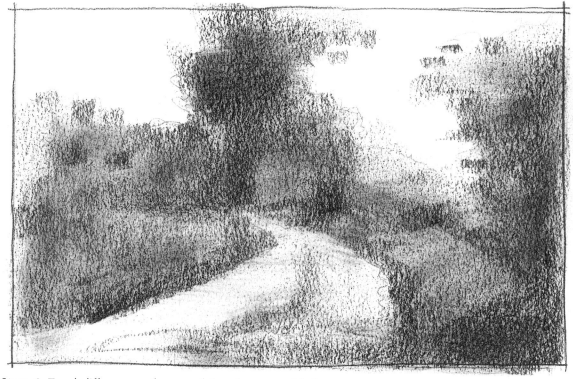

Stage 2 *Tonal differences of some of the elements added.*

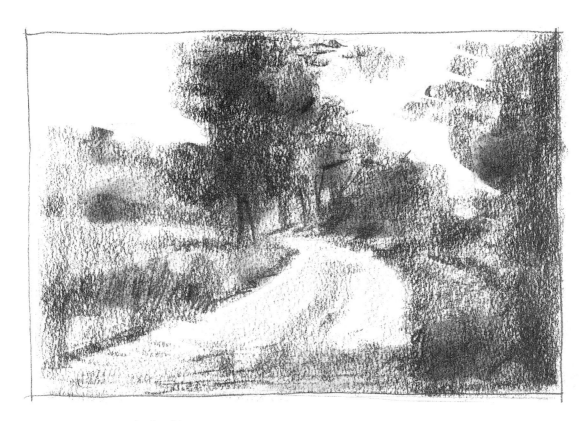

Stage 3 *More tonal 'depth'.*

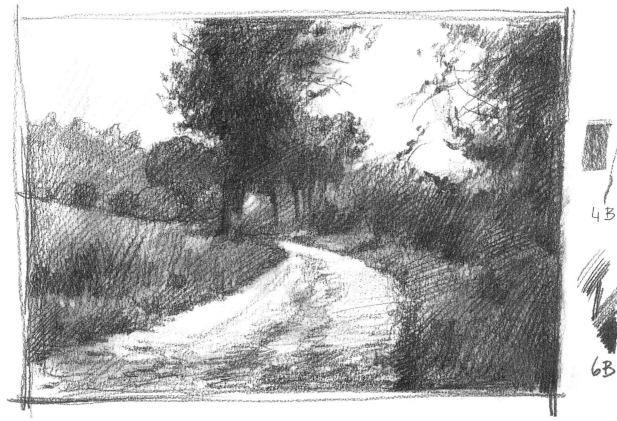

4B

6B

Stage 4 *Further tonal shading added.*

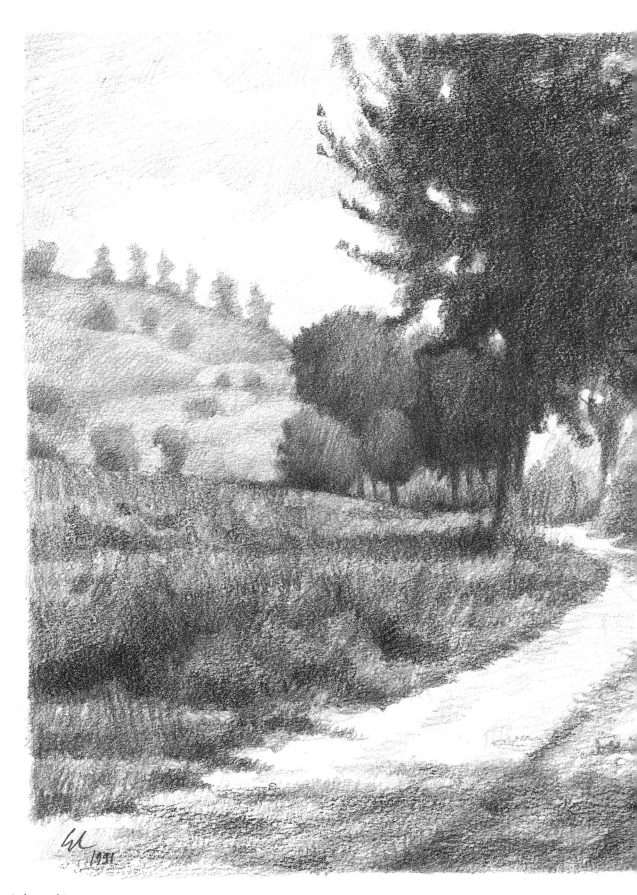

Soft graphite on Not paper, 33 x 48cm (13 x 19in).

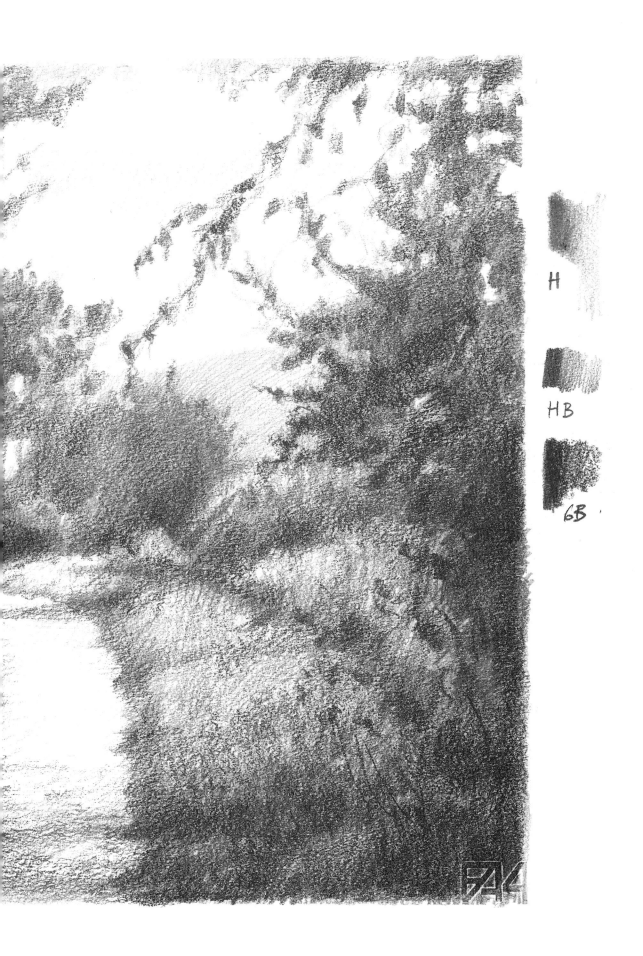

H

HB

6B

PRELIMINARY STUDIES

Drawing can be an autonomous means of expression, with its own intrinsic qualities and values, or it can be a clever tool to study reality, to make visual notes, and to solve compositional problems. It can be, in short, a 'preliminary' study, done as preparation for a more complex work, whether another drawing or a painting.

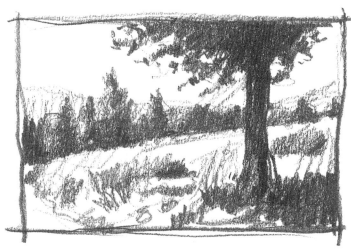

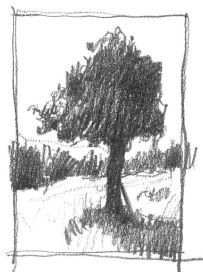

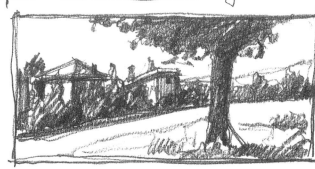

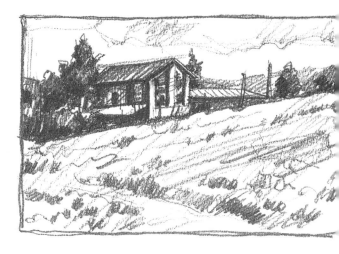

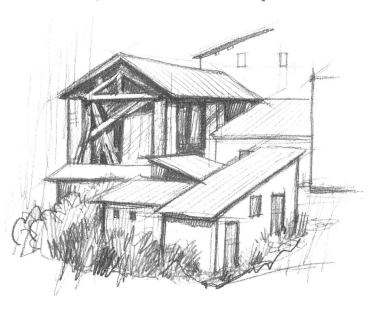

On this page I have put together some drawings sketched from life on a landscape theme: note how I have 'moved around' the subject, looking for the most suitable viewpoint; how I have tried to replace, eliminate or move certain elements (houses and trees); how I have observed in more detail the architecture of a little cottage, and so on. When going on country walks, always carry a pencil and a pocket sketchbook and draw lots of sketches which will prove useful as visual notes, when you set out to paint or conjure up complex scenes. Many artists also carry a camera which is indispensable for collecting a library of reference scenes and details – but remember that photography is a tool, not a substitute for drawing.

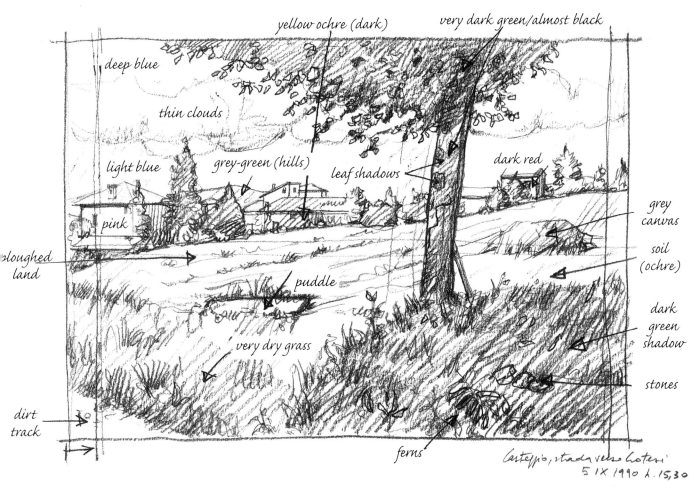

deep blue

thin clouds

light blue

pink

ploughed land

dirt track

yellow ochre (dark)

grey-green (hills)

very dark green/almost black

leaf shadows

dark red

puddle

very dry grass

ferns

grey canvas

soil (ochre)

dark green shadow

stones

Castepio, strada verso Croteri
5 IX 1990 h. 15,30

When you sketch a quick preliminary study in preparation for a painting, take down plenty of information on colours, details of the surroundings, the structure of complex elements, light and weather conditions, etc.

To enlarge a little sketch or photograph to the size wanted, you can use a simple tool called a 'grid of squares', which allows a quick and accurate transfer of the main outlines of an image. It is an intuitive process. Draw light parallel lines to subdivide the original surface into small squares and then transfer the same number of squares on to the canvas, or a bigger sheet, as indicated on the diagram on the right. It is easy to draw on each square the corresponding strokes from the original. The whole drawing will be enlarged in proportion.

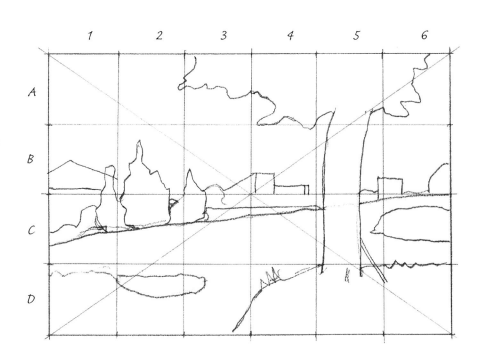

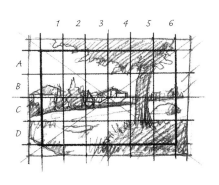

DETAIL

If you have already experimented with drawing scenery, you will have
realised that not everything you see lends itself to drawing. For instance, a
large scene can be enchanting with regard to colour, yet look insignificant
when we try to draw it. Or the opposite can happen, whereby an apparently
unattractive landscape turns out to be unexpectedly interesting when we
start drawing it. The same principles can in part be applied to photography.
This is, in effect, an extremely complex problem to do with visual
perception, psychology and artistic experience. The main difficulty,
however, lies in transferring three-dimensional reality to a two-dimensional
surface without losing the scene's feeling of depth. Sometimes one or two
elements from a large scene can be worked up into an effective drawing of
their own. In the 'panoramic' drawing shown below, the foreground has
limited prominence, is part of the total scene and even the sharpness of the
detail is secondary to its tonal and perspective relationship with the other
elements (rocks, sea, and so on). The same foreground (opposite), taken out
of context, acquires an importance and graphic meaning of its own and
requires a more detailed rendering.

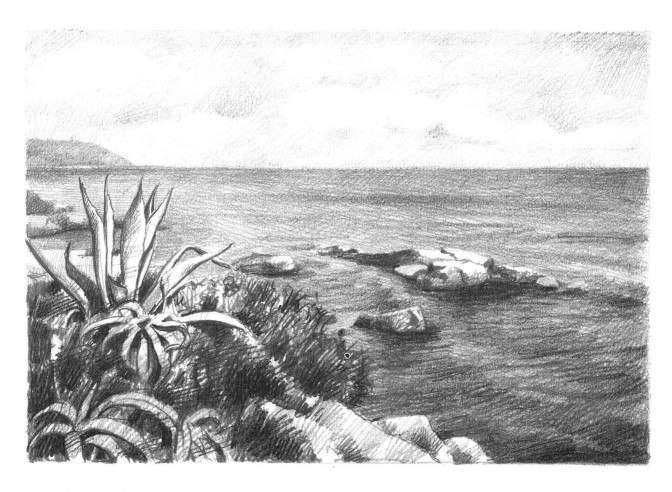

HB and 2B pencils on Not paper, 28 x 19cm (11 x 7½ in).

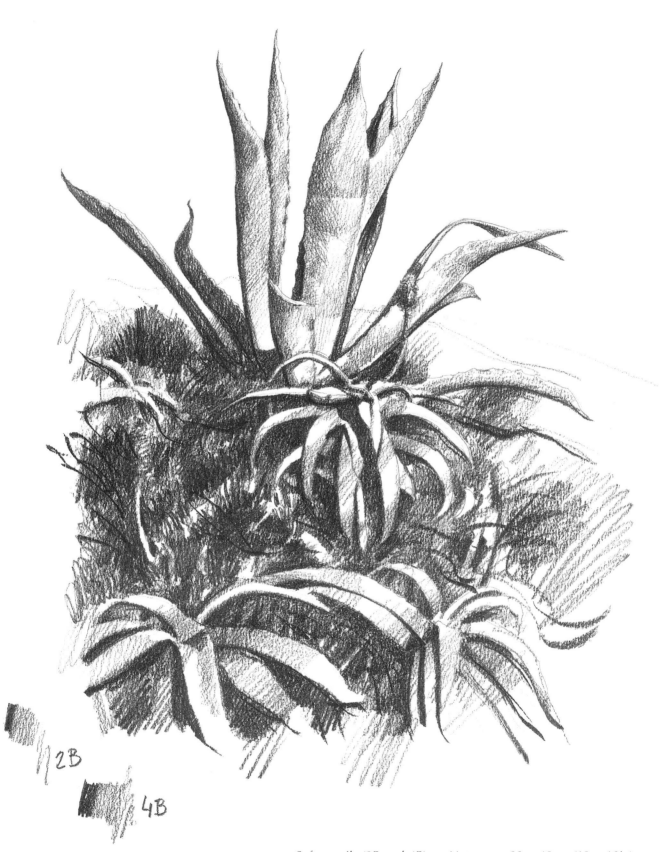

2B

4B

Soft pencils (2B and 4B) on Not paper, 33 x 48cm (13 x 19in).

LIGHT

As light is of prime importance to the artist, you should pay a lot of attention to the sun's effect on a scene. The direction of the shadows varies according to the time of day, as shown in the diagrams below, and in the sketches on the opposite page. If possible, look at the same scene in different weather conditions – broad sunlight; dimmed by clouds; rain; snow; fog and so on.

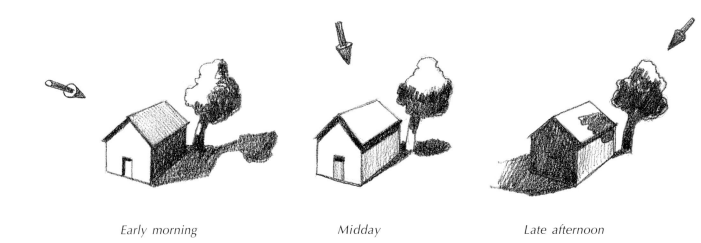

Early morning *Midday* *Late afternoon*

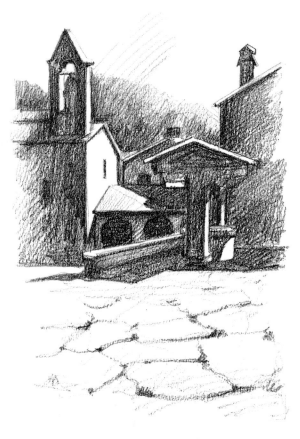

Direct sunlight with cloudless sky.

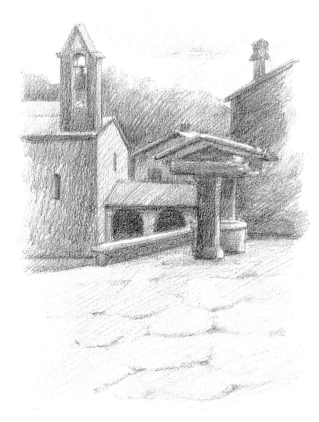

Indirect sunlight with cloudy sky.

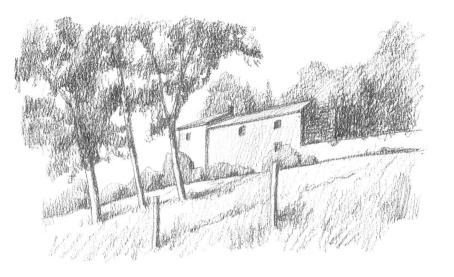

Hill scene sketched in autumn, in the first hours of the morning. At dawn, the sun is low on the horizon and creates long shadows with weak tonal contrasts as the atmosphere is bright and clear.

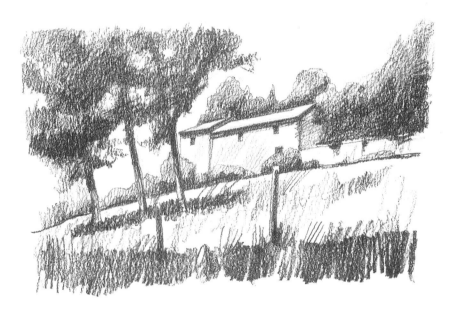

The same scene drawn at about midday. The sun is almost vertical and creates sharp shadows at the foot of the objects (houses, trees, etc). The tonal contrasts are fairly strong; the whole landscape appears brighter and colours are at their most intense.

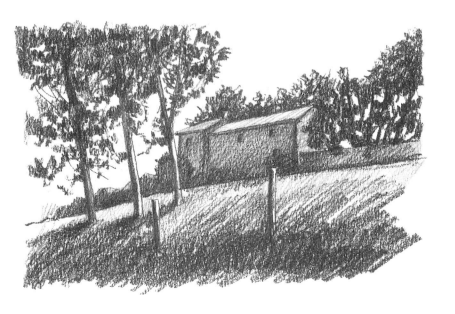

The same scene drawn in the late afternoon. At sunset the sun is again low on the horizon creating strong, long shadows and causing a strong tonal contrast between the sky (very bright) and the other elements of the landscape (dark because of the shade) silhouetted against the light.

WATER

Water can also be an important element of a scene. I have already mentioned the perspective problems of reflections (pages 10 and 11) but here I suggest you simply study water in those situations which are of compositional interest: waves; boats in the harbour; ponds; fountains; streams etc. Waves are caused by wind and reach various heights. When they come close to the shore they look like those shown in the sketch below. The 'crest' juts out in front of the wave and then falls upon it, forming the characteristic breaker which dissolves into foam. When you draw the sea, do not attempt to compete with a photograph in its meticulous representation of detail, but rather suggest the feeling of perpetual movement by drawing short, sketchy strokes in a horizontal direction.

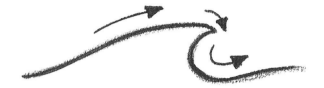

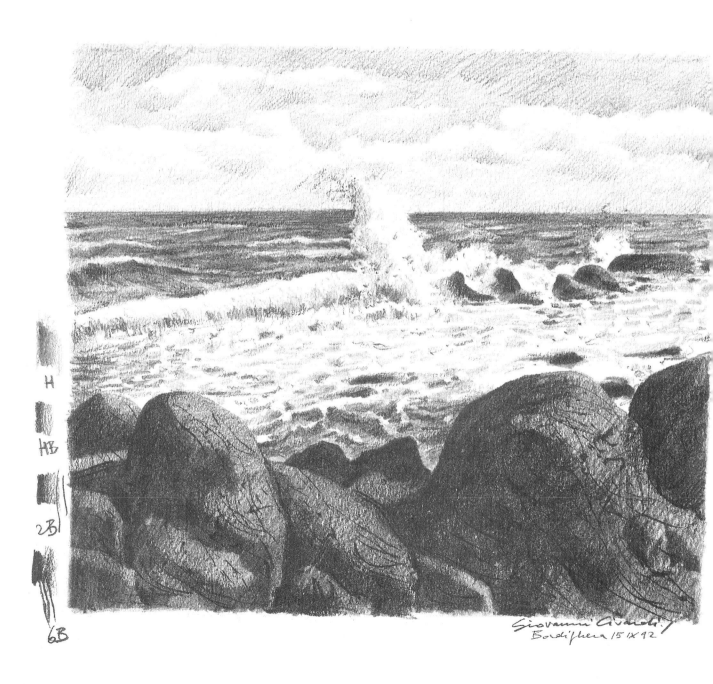

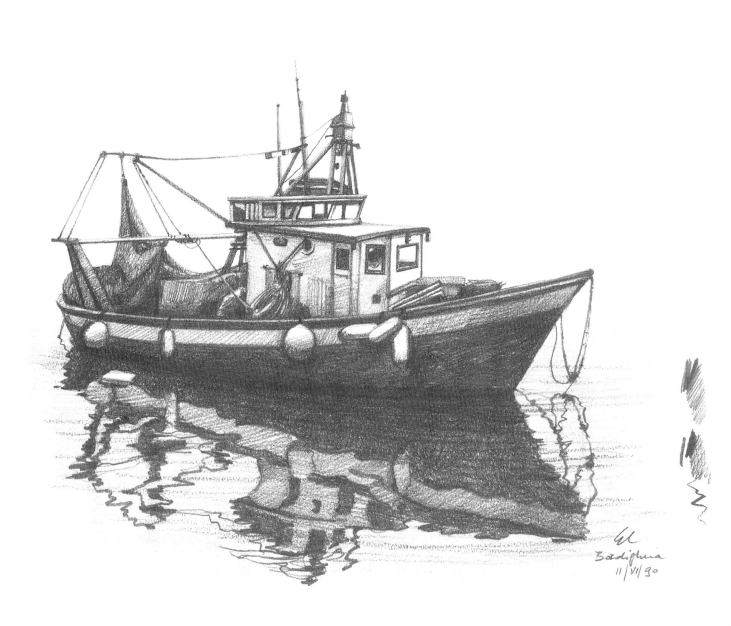

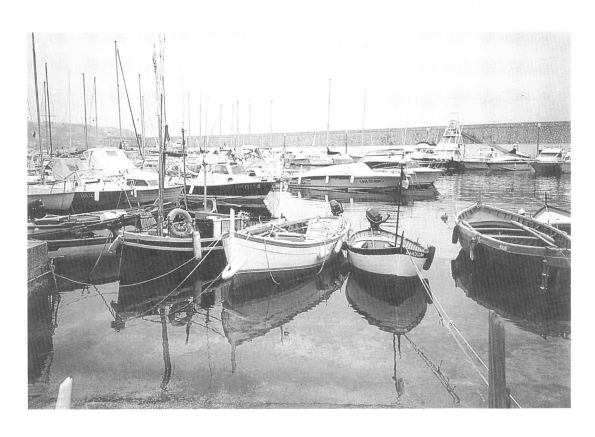

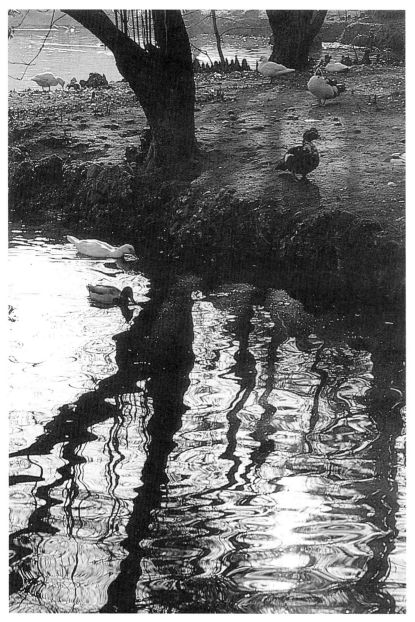

Small ponds and fountains in public parks and gardens are subjects which are both picturesque and easy to find. Practise interpreting these photographs using various media (charcoal, pencil, watercolours, etc.), enlarging them using the 'grid of squares' technique (see page 33), and then look for similar subjects in your own neighbourhood and draw them from life.

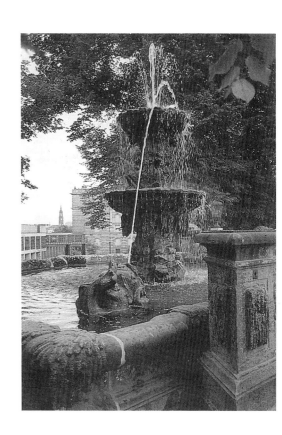

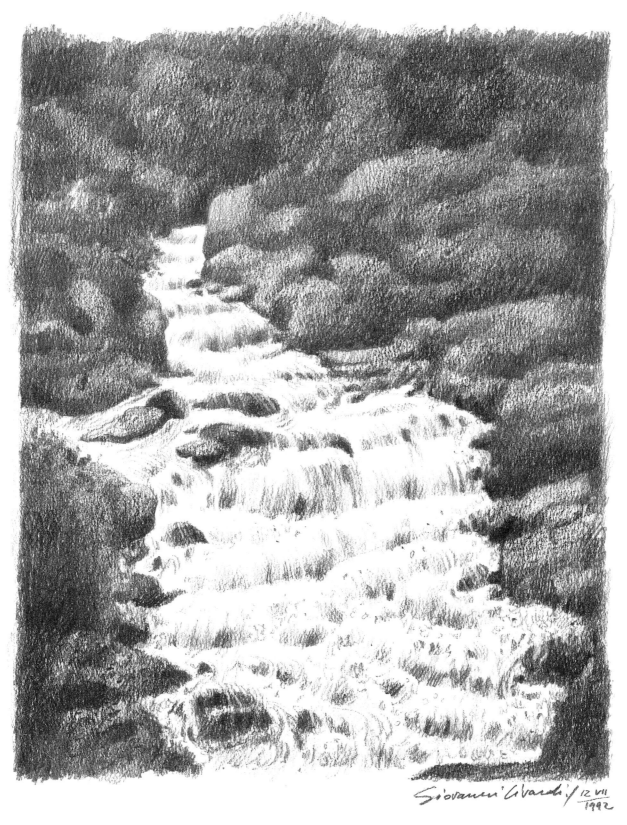

Little Stream. Pencil on Not paper, 30 x 40cm (12 x 16in).
Short pencil strokes in the direction of the current are
enough to suggest the waterfalls and the water breaking
on the rocks.

TREES AND VEGETATION

In almost all landscape drawings you will have to represent trees, woods, shrubs and flowers. Vegetation is extremely varied and you need to study it carefully from life to be able to draw it convincingly. Here I limit myself to a few suggestions. When drawing a tree, notice first its general shape, especially its outline (see the sketches on the opposite page); try to understand the direction its trunk and main branches grow and the structure of its bark and leaves. Then I suggest you follow these three stages: firstly, outline the profile; secondly, indicate the most relevant, yet significant, subdivisions of the foliage, and thirdly, sketch some of the foliage detail.

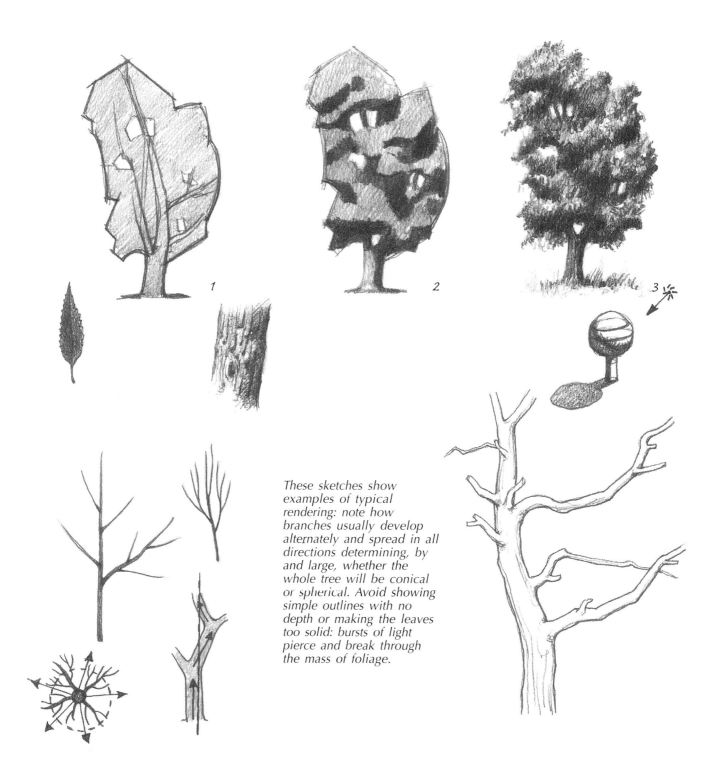

These sketches show examples of typical rendering: note how branches usually develop alternately and spread in all directions determining, by and large, whether the whole tree will be conical or spherical. Avoid showing simple outlines with no depth or making the leaves too solid: bursts of light pierce and break through the mass of foliage.

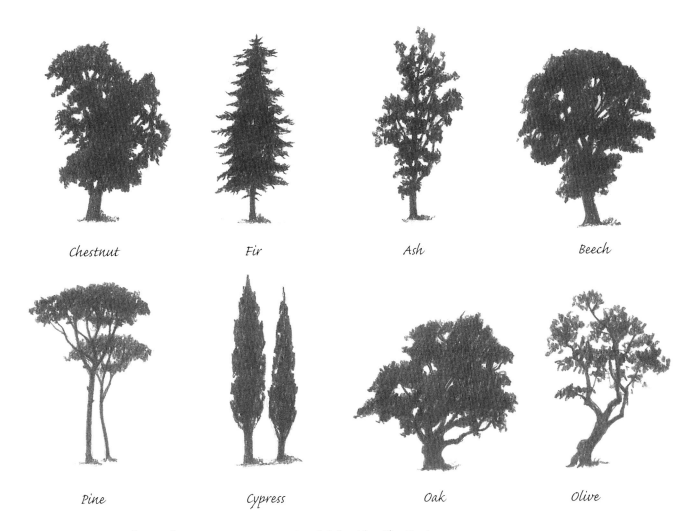

Chestnut Fir Ash Beech

Pine Cypress Oak Olive

The characteristic outlines of some common trees (useful for identification).

The photographs below show the same tree taken in winter, after shedding its leaves, and during its spring blooming. Carefully compare the two pictures and notice the radical transformation which has taken place.

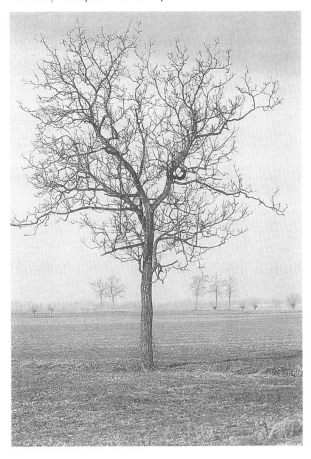

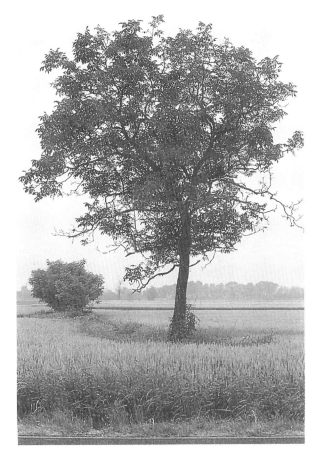

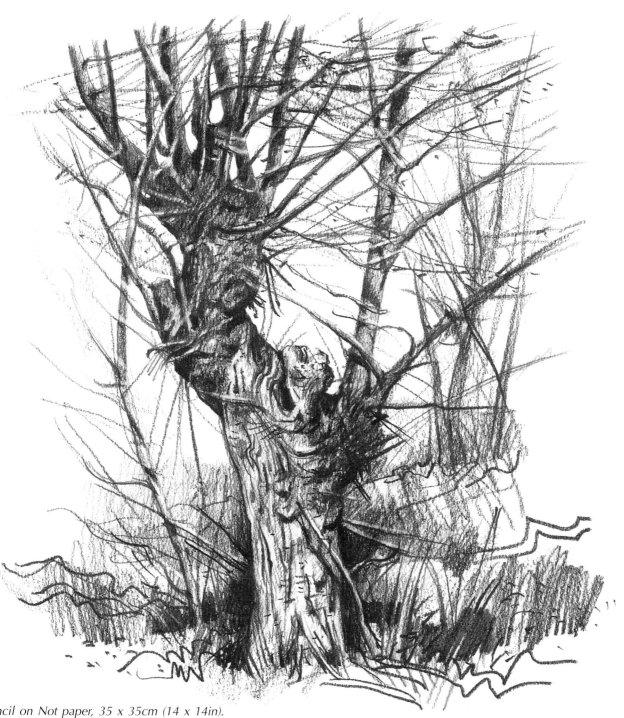

6B pencil on Not paper, 35 x 35cm (14 x 14in).
Trunks are fascinating subjects to draw. Understand their structure and general direction, then examine the texture of the bark. Use soft grade pencil or charcoal.

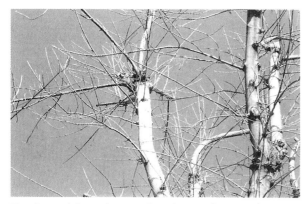

Trunks and branches evoke almost abstract shapes.

Grasses and shrubs.

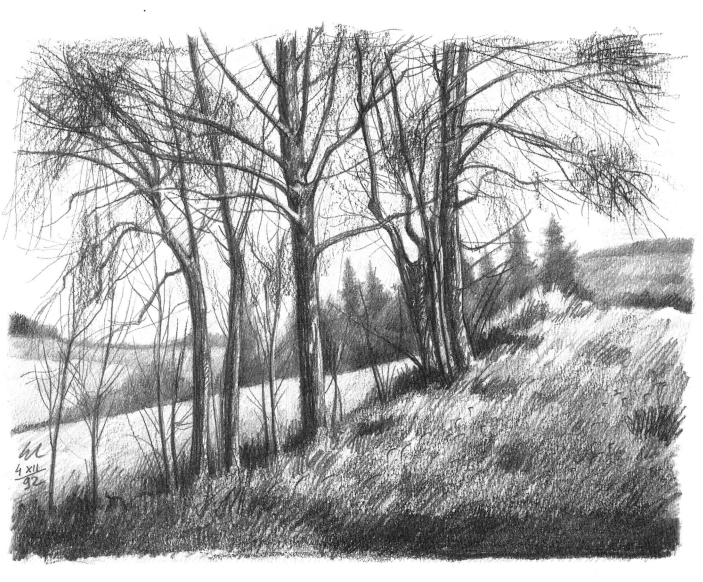

Trees on the edge of a Wood. Pencil on paper, 25 x 30cm (10 x 12in).

Compare the drawing with the photograph below, which shows the subject from a slightly different viewpoint.

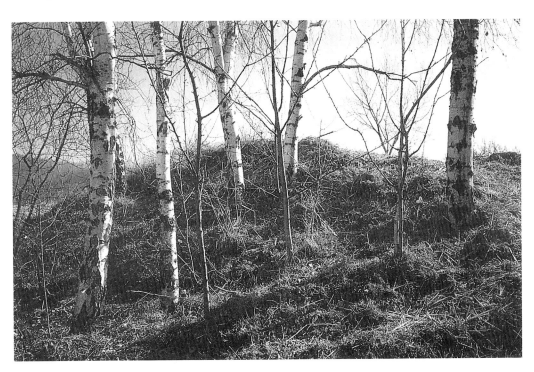

BUILDINGS AND STRUCTURES

It is rare to find a scene which doesn't feature something man-made, whether it is a house, bridge, road, or farm machinery. You will have to place these elements in your drawing. When drawing buildings, start with a thorough perspective sketch to highlight architecture, monuments and urban vistas. Buildings in the distance should be sketched in broad shapes, without much detail, while those in the foreground must be drawn precisely. Bear in mind the relative proportions of people to buildings. The adjacent diagrams show the relationship between a man's height and the door, window, and front elevation of a house.

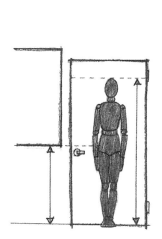
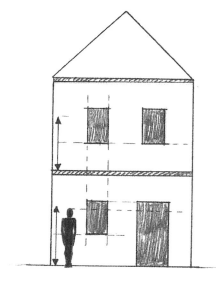

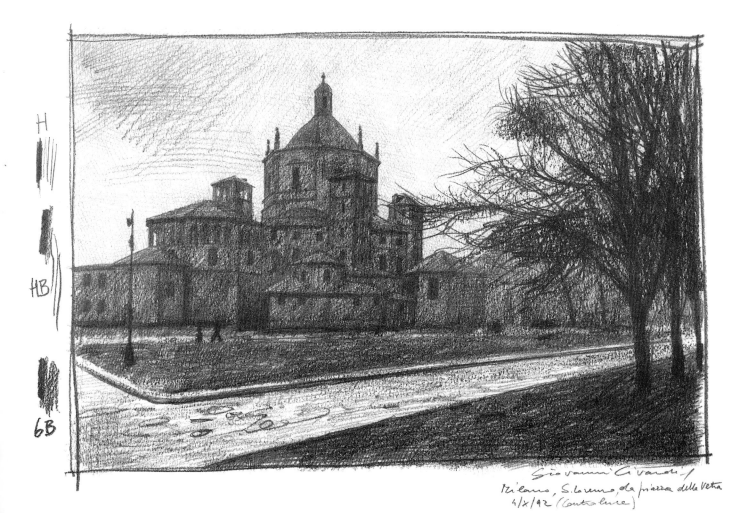

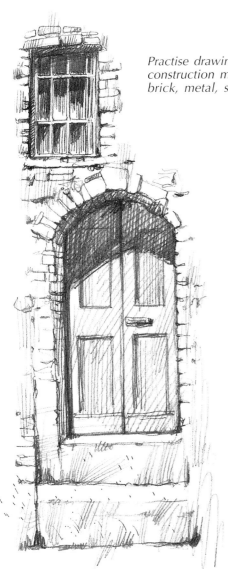

Practise drawing the details of buildings close up. This helps you to understand construction methods and to notice the characteristics of different materials (wood, brick, metal, stone etc.)

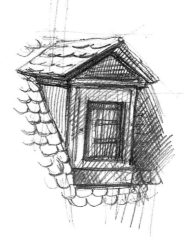

Dormer window

Door and small window of an old Tuscan house. The position of the window, which looks odd at first, makes sense when it turns out to be the skylight of a staircase. Study these curious characteristics from life – you will often come across them in old country houses.

Chimney

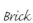

Brick

Massive rock wall and low stone wall. The materials of each are similar but the dimensions are quite different. In many cases it is necessary to introduce elements of scale (in this case, a man and a flower).

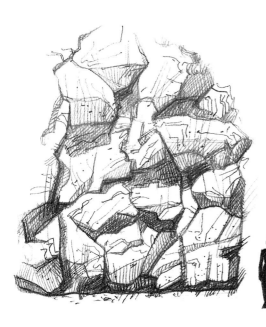

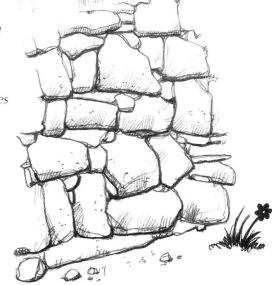

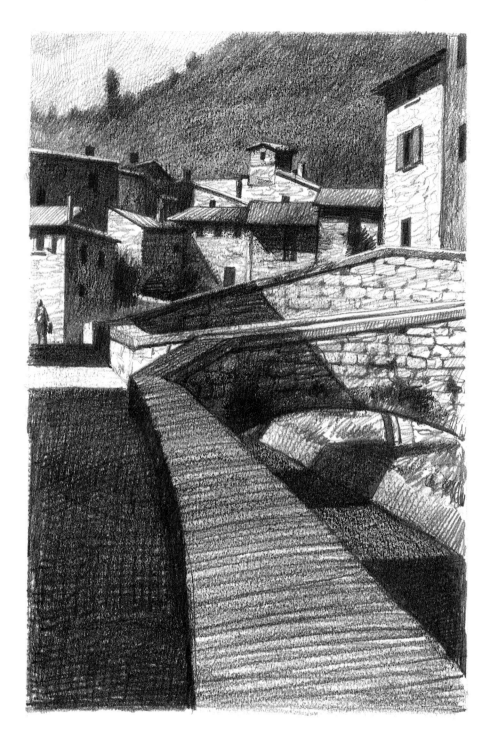

I sketched this little pencil study in a village in Tuscany. What appealed to me was the unusual perspective of the vista. The architectural elements are secondary to the geometric rhythm of the houses, and to the alternating of light and shade. The hilly background is rendered out of focus by finger-smudging the pencil strokes, while the other planes are defined more clearly as they get closer. You can see the texture of the stones in the wall of the little bridge, but I barely hinted at these details when drawing the walls of the houses in the distance. I crosshatched with a soft pencil to achieve increasingly darker tones.

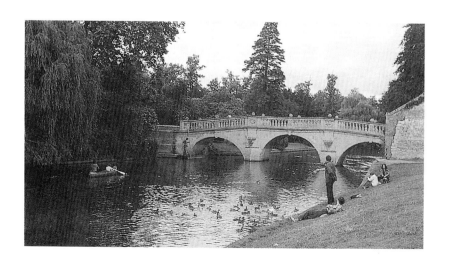

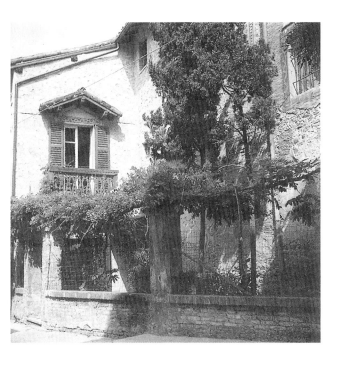

During walks in search of interesting urban scenes, take some photographs but, above all, draw plenty of sketches.

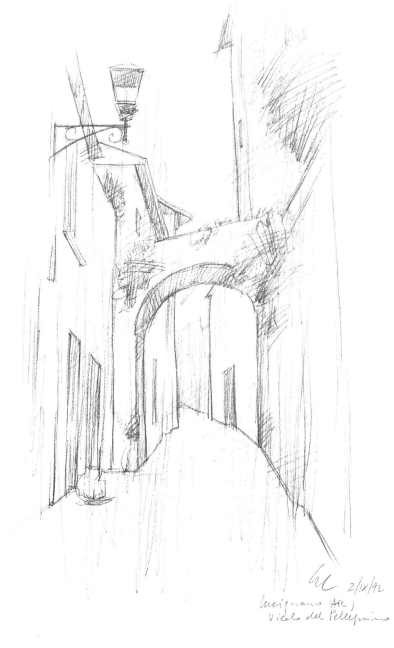

CLOUDS AND SKY

Clouds' shape, consistency and position change so rapidly that only by observing their natural appearance carefully can you work out how to represent them convincingly. The sketches below will help you recognise the various types of clouds, and point out features useful for drawing. Draw close strokes in soft pencil using even pressure and blending well. Smudging is not necessary, except to achieve soft and misty effects, as it is better to keep a certain shape and structure to clouds.

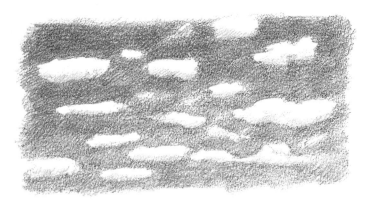

Cirrus *have a stringy or 'necklace-like' appearance. They are found at very high altitudes.*

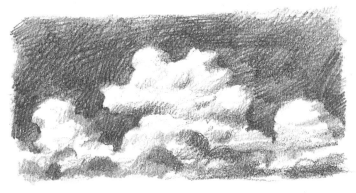

Cumulus *appear as banks of partly superimposed clouds with a rounded outline. They are found at low altitudes.*

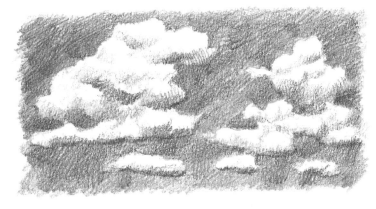

Nimbus *are very dense formations with a jagged outline, very tall and dark. They are found at low altitudes.*

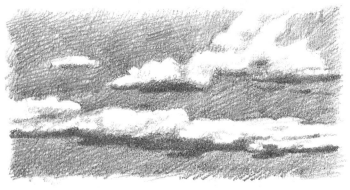

Stratus *appear thin and elongated and are found at medium altitudes.*

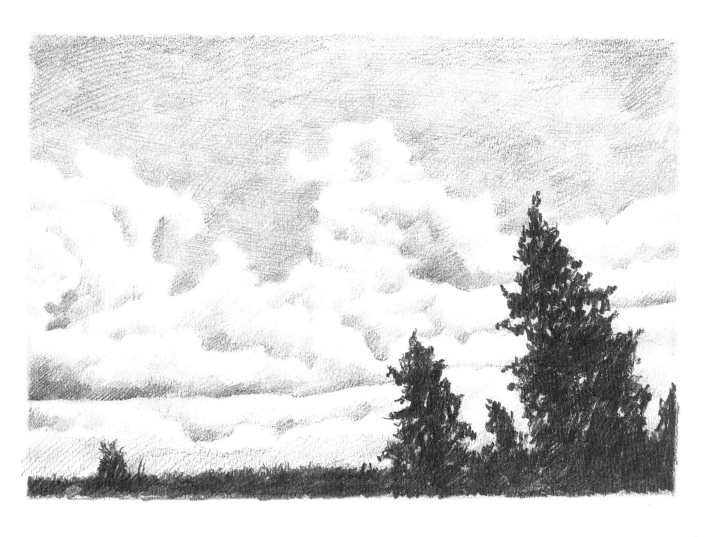

4B pencil on paper, 25 x 35cm (10 x 14in).
This study of a cloudy sky is partly based on photographs but also on many
sketches from life. It highlights the tonal contrast between the dark tree-lined
foreground and the intensely bright sky.

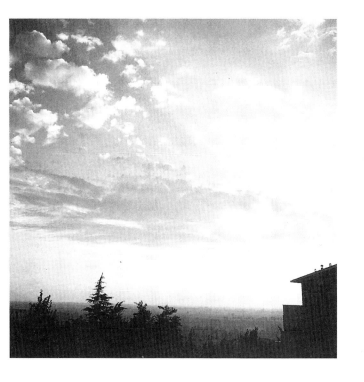

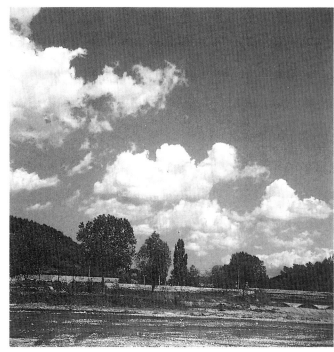

REFERENCE MATERIAL

I mentioned on page 32 how useful it is to sketch lots of little studies from life while you are out and about in search of views to draw. I believe that drawing, even a quick sketch, has invaluable meaning for the artist. However, photographs can be useful for collecting reference material when we have limited time at our disposal or we need to capture fleeting images. Do not neglect, then, to take plenty of photographs. Bear in mind the drawings you will make from them and choose viewpoints and compositions accordingly.

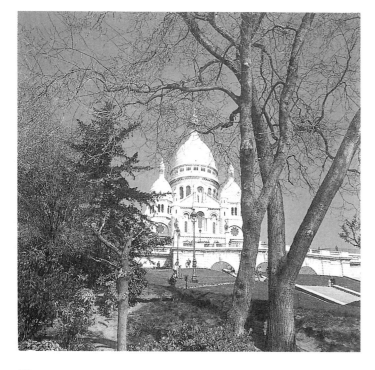

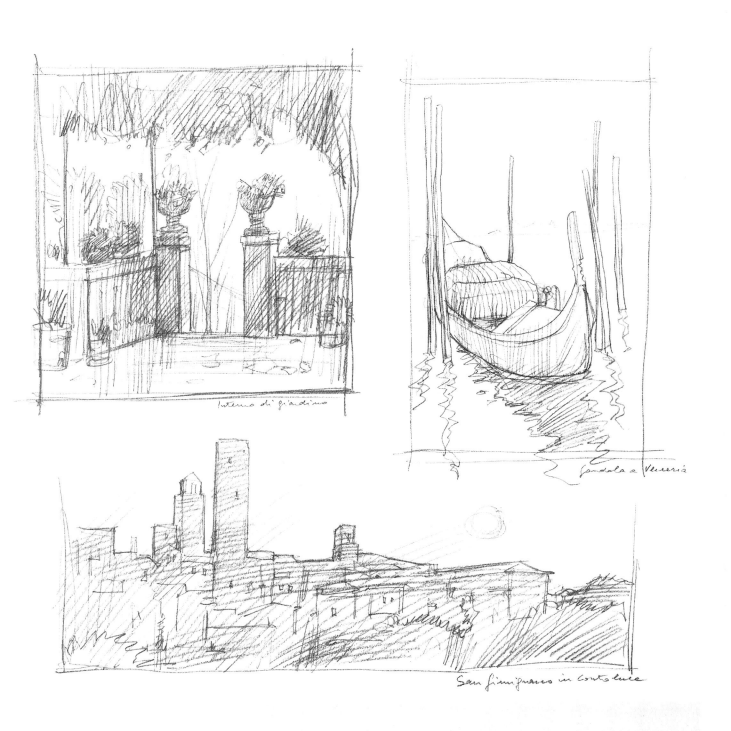

Interno di giardino

Gondola a Venezia

San Gimignano in controluce

The sketches and photographs you see on these two pages come from my 'visual notes' file in which, over the years, I have assembled a large and varied collection of themes and subjects related to landscapes, seascapes and buildings.

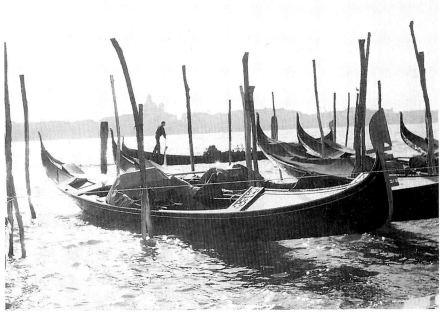

FIGURES AND ANIMALS

If you want to draw the surrounding environment and scenes of everyday life you will need to introduce figures and/or animals. These subjects are as fascinating as they are complex to draw. For the moment I would like to reassure you by saying that, in drawing scenes human beings do not usually need more attention than the other elements. You should pay particular attention to scale (note that the total height of a person corresponds to seven and a half times the height of their head); the overall look, and characteristics of the subject.

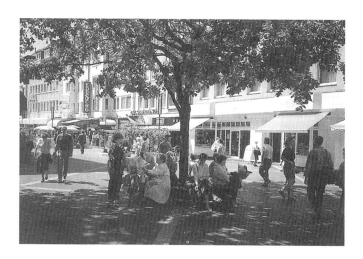

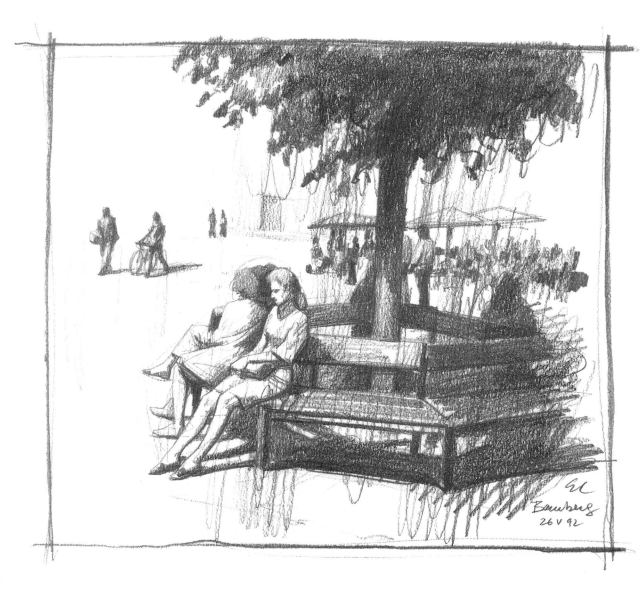

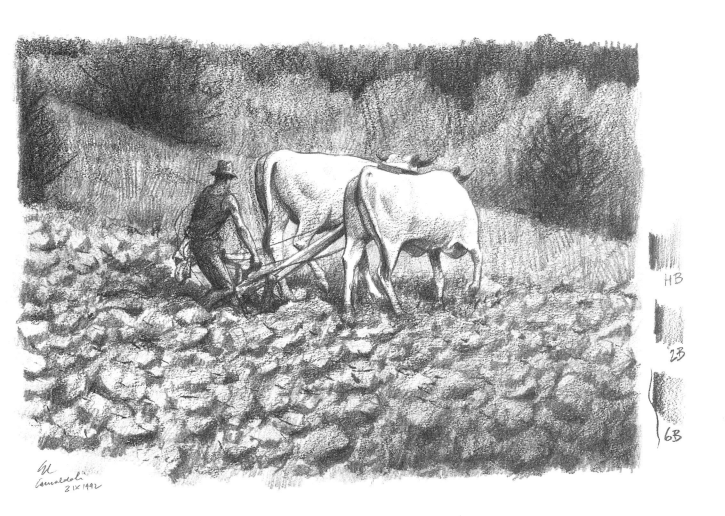

HB

2B

6B

When you need to add figures to a scene you can, at least to begin with and to simplify any problems, refer to good photographs. Start with a detailed sketch, possibly with the help of a 'grid of squares' and use hard pencil on medium size paper. With practice, and once you feel fairly confident, you can move on to doing studies from life. On these two pages I have compared each sketch, drawn fairly quickly, with a photograph of a similar subject which has lots of detail, sometimes secondary or unnecessary.

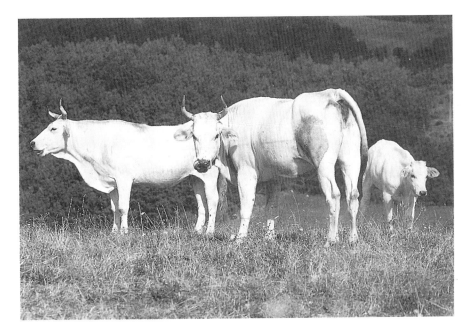

LANDSCAPES

Landscapes, with their wide open spaces, cultivated fields and gentle slopes, have always evoked in the artist and the viewer alike a feeling of natural peace and human industry. More than other terrains, they epitomise man's work on the land. Try, then, to portray in your sketchbook features that are characteristic of the rural environment: ploughed or planted fields; trees, isolated or in a row; hedgerows; farmhouses; little villages, and clouds in the wide expanses of sky.

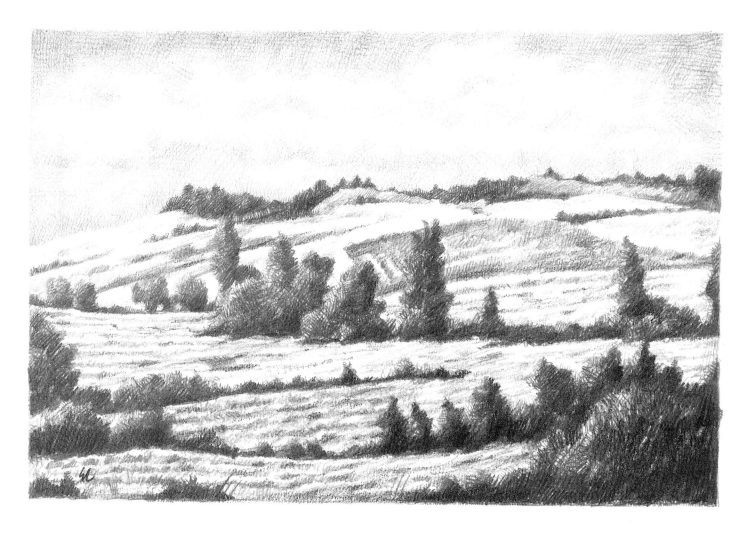

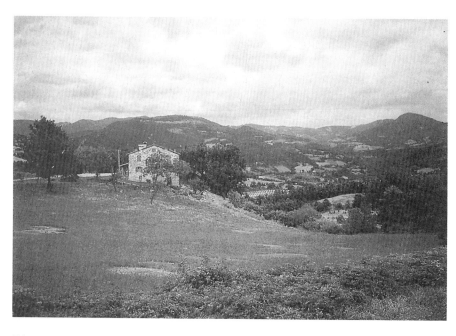

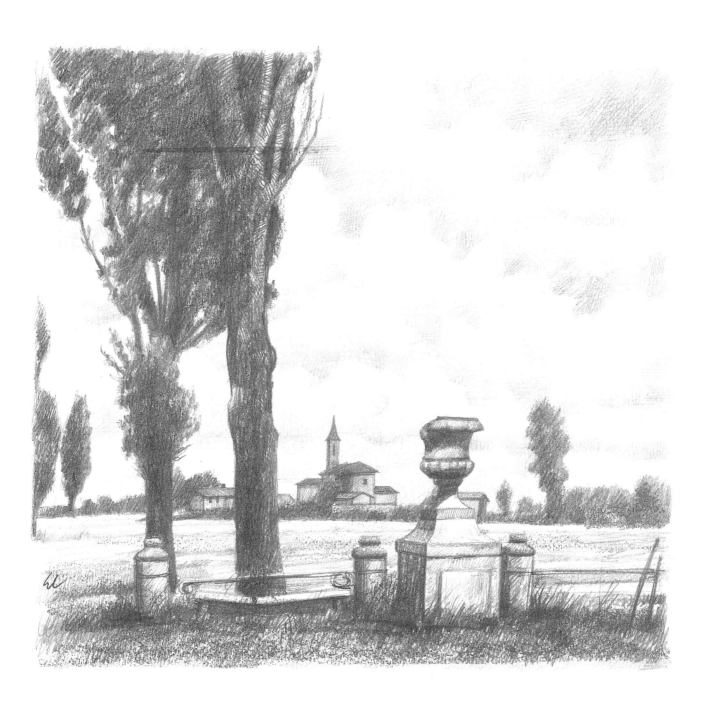

Pencil and charcoal are the ideal media for drawing landscapes as they allow you to portray their characteristics concisely, therefore maintaining the effect of spatial depth. The drawings on these two pages have been done with 4B pencil on Not paper. Note the direction of the pencil strokes which suggest, at intervals, the terrain's uneven surface and the masses of vegetation. The photographs show other subjects you can take inspiration from.

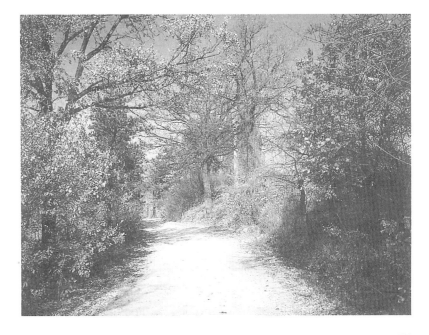

SEASCAPES

The sea is the main subject of a whole genre of painting, the seascape, which also includes boats, ships, reflections, harbours, etc. Before you start drawing the sea, notice the direction and the formation of waves and how they break upon the shore. On a sheet of paper leave just a little room for the sky and concentrate your attention on the watery mass. The distant waves should be sketched concisely, with short, horizontal strokes, not too blended together. The waves in the foreground, however, require a more accurate 'build-up' with short and well-defined strokes suggesting, by their direction, the shape of the wave. Soft pencils and charcoal are both suitable for drawing the sea but watercolours are best at capturing the 'liquidity' of the subject. Keep your drawing simple and concise, avoiding minute, photographic details which weaken the overall structure of the study.

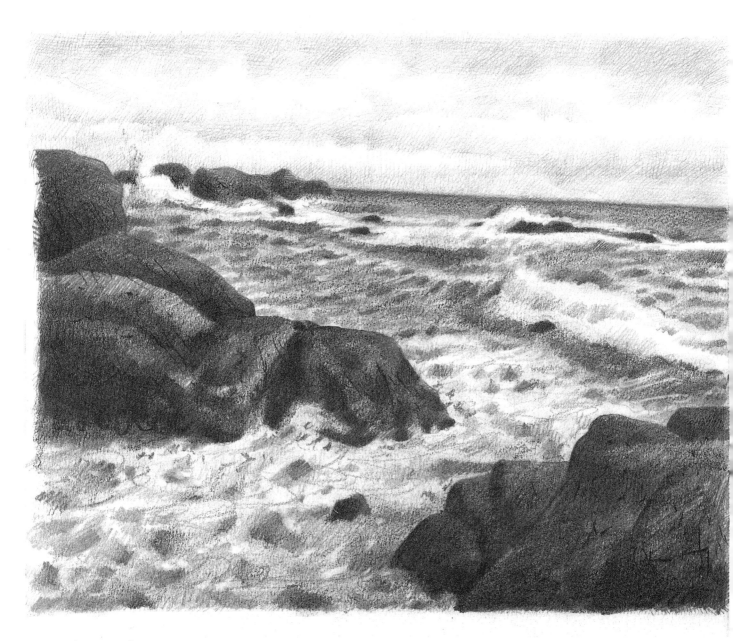

HB and 4B pencil on Not paper, 30 x 33cm (12 x 13in).

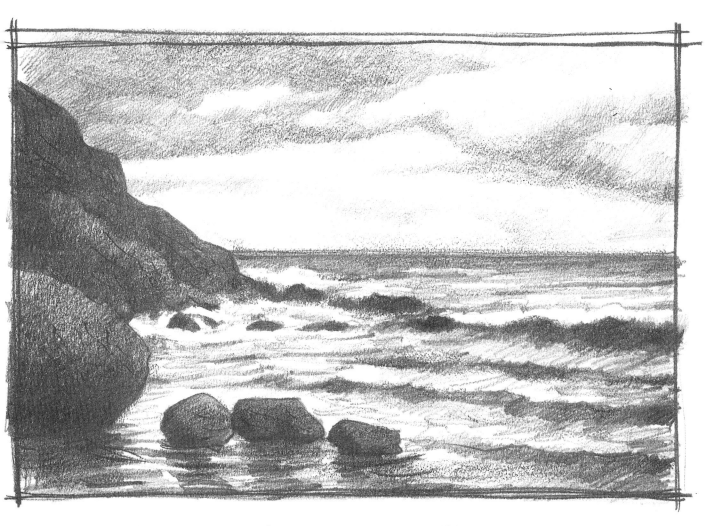

Study in preparation for a painting. 6B pencil on paper, 20 x 32cm (8 x 12½in).

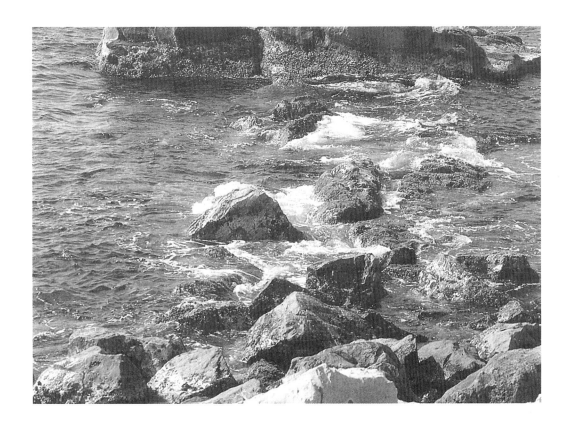

URBAN AND INDUSTRIAL LANDSCAPES

Nearly all of us live in built-up areas – cities, towns or villages. The artist can find many interesting themes in the urban landscape – ancient or very modern buildings, monuments, glimpses of traffic-packed streets, squares, tree-lined avenues, etc. Every city has spots which are 'characteristic'. Do not be afraid that you will end up with banal or 'postcard-style' sketches if you tackle very well-known subjects. Rather, try to convey something of the historic and social atmosphere of a place. Successful artists find unusual features even in well-known tourist spots, which need extra attention if one is to avoid being repetitive.

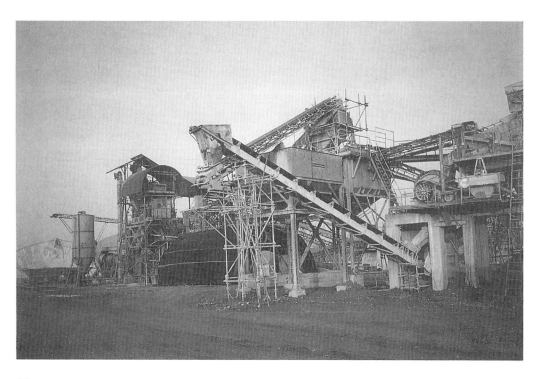

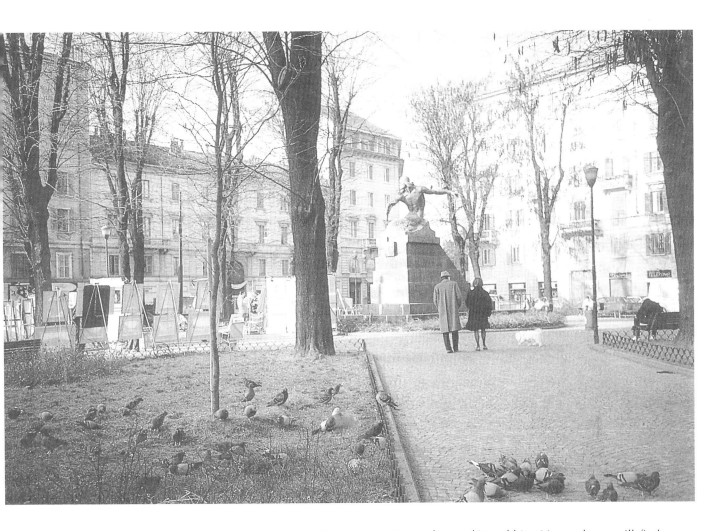

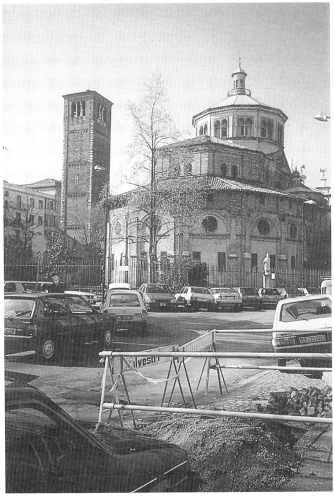

Go to the outskirts of big cities and you will find factories, plants, gasometers, railway tracks etc, often bathed in fumes and mist, the irregular and unusual shapes of which will present many possibilities. They may lack the romance of a traditional landscape, but they have their own beauty, their own expressive power which justifies a figurative work, especially if you succeed in conveying the characteristic 'atmosphere' of these places. Try using pen and ink and practise drawing, taking your inspiration from photographs or life. After you have done a few little sketches to sort out any perspective or compositional problems, do a concise but accurate, light drawing on a sheet of good quality paper of average size using pencil. Then working with a pen, using it freely and fluently, draw the outline of the buildings. Finally, introduce shadows by crossing or thickening the hatching or staining with diluted ink.

MOUNTAINS

Only by visiting one of the bigger mountain ranges can you fully appreciate the impressiveness of mountains. The sculptural power of these masses of rock, the contrast between the brilliant white of the snow and the dark shadows of the crevices and the cracks, and the sloping woods and meadows, provide many potential scenes and call for clean drawing, rich in tonal contrasts. Use a soft pencil (charcoal and pen are less effective) and fairly rough paper, pay attention to aerial perspective, and make sure you deal with the various elements differently (rock, grass, trees, snow, ice, etc.). For example, when drawing rocks, especially in the foreground, you need to hint at their rough, irregular texture with hatching or cross-hatching, dotting and the odd mark; short, vertical pencil strokes work well for meadows and trees; lit patches of snow can be suggested by leaving the paper white while strengthening some of the shadows to give thickness and texture to the mantle.

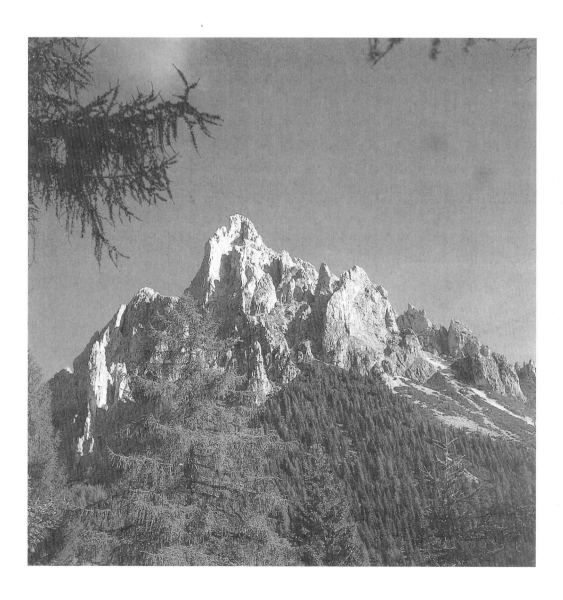

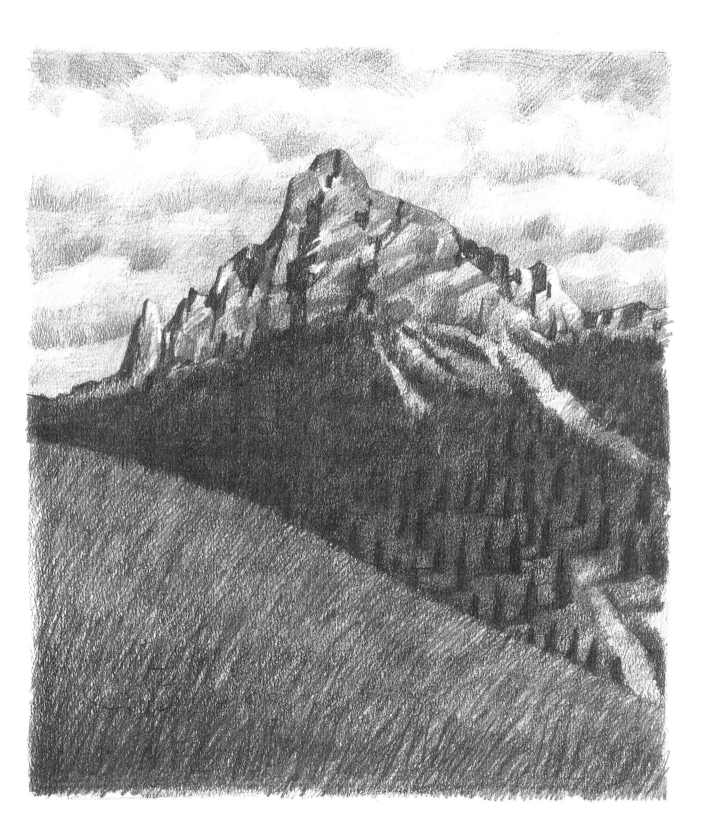

The Dolomites in Summer. Soft pencil on paper, 30 x 40cm (12 x 16in).

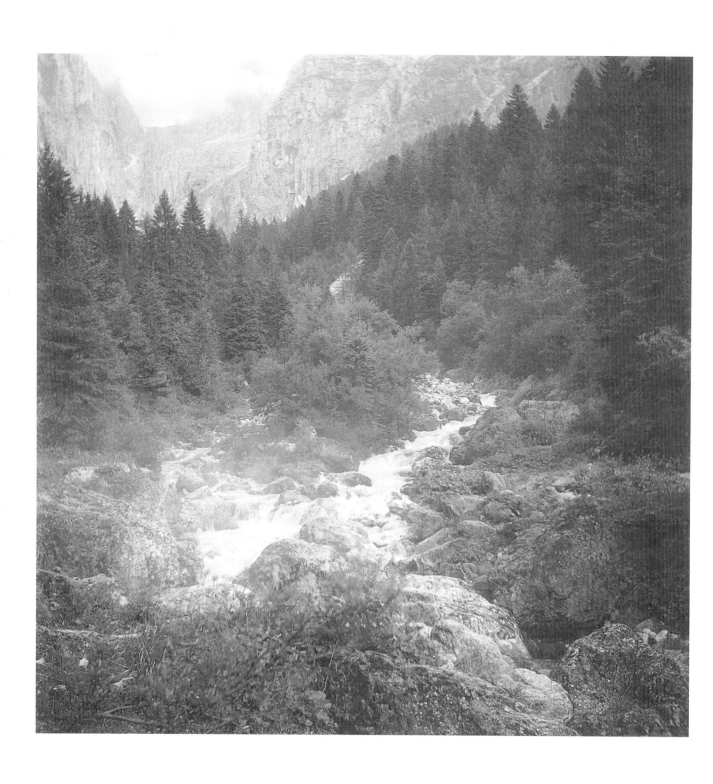